## Endorsements for the Flourish Bible Study Series

"The brilliant and beautiful mix of sound teaching, helpful charts, lists, sidebars, and appealing graphics—as well as insightful questions that get the reader into the text of Scripture—make these studies that women will want to invest time in and will look back on as time well spent."

**Nancy Guthrie,** Bible teacher; author, *Even Better than Eden*

"As a women's ministry leader, I am excited about the development of the Flourish Bible Study series, which will not only prayerfully equip women to increase in biblical literacy but also come alongside them to build a systematic and comprehensive framework to become lifelong students of the word of God. This series provides visually engaging studies with accessible content that will not only strengthen the believer but the church as well."

**Karen Hodge,** Coordinator of Women's Ministries, Presbyterian Church in America; coauthor, *Transformed*

"If you're looking for rich, accessible, and deeply biblical Bible studies, this series is for you! Lydia Brownback leads her readers through different books of the Bible, providing background information, maps, timelines, and questions that probe the text in order to glean understanding and application. She settles us deeply in the context of a book as she highlights God's unfolding plan of redemption and rescue. You will learn, you will delight in God's word, and you will love our good King Jesus even more."

**Courtney Doctor,** Coordinator of Women's Initiatives, The Gospel Coalition; author, *From Garden to Glory* and *Steadfast*

"Lydia Brownback's Bible study series provides a faithful guide to book after book. You'll find rich insights into context and good questions to help you study and interpret the Bible. Page by page, the studies point you to respond to each passage and to love our great and gracious God. I will recommend the Flourish series for years to come for those looking for a wise, Christ-centered study that leads toward the goal of being transformed by the word."

**Taylor Turkington,** Bible teacher; Director, BibleEquipping.org

"Lydia Brownback has a contagious love for the Bible. Not only is she fluent in the best of biblical scholarship in the last generation, but her writing is accessible to the simplest of readers. She has the rare ability of being clear without being reductionistic. I anticipate many women indeed will flourish through her trustworthy guidance in this series."

**David Mathis,** Senior Teacher and Executive Editor, desiringGod.org; Pastor, Cities Church, Saint Paul, Minnesota; author, *Habits of Grace*

# 1–2 PETER

Flourish Bible Study Series
By Lydia Brownback

*Esther: The Hidden Hand of God*

*1–2 Peter: Living Hope in a Hard World*

**FLOURISH**
**BIBLE STUDY**

# 1–2 PETER

LIVING HOPE IN A HARD WORLD

LYDIA BROWNBACK

WHEATON, ILLINOIS

*1–2 Peter: Living Hope in a Hard World*

Copyright © 2021 by Lydia Brownback

Published by Crossway
        1300 Crescent Street
        Wheaton, Illinois 60187

Cover design: Crystal Courtney

First printing 2021

Printed in China

Trade paperback ISBN: 978-1-4335-6669-1

Crossway is a publishing ministry of Good News Publishers.

| RRDS | | 30 | 29 | 28 | 27 | 26 | 25 | 24 | 23 | 22 | 21 |
|------|------|------|------|------|------|------|------|------|------|------|------|
| 15 | 14 | 13 | 12 | 11 | 10 | 9 | 8 | 7 | 6 | 5 | 4 | 3 | 2 | 1 |

With gratitude to God
for the friendship and godly encouragement
of fellow sojourner and exile
Elaine Bridget Garrett

# CONTENTS

# THE TIMING OF 1 AND 2 PETER

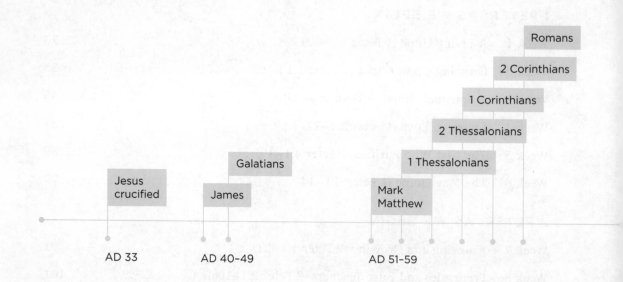

Romans

2 Corinthians

1 Corinthians

2 Thessalonians

1 Thessalonians

Galatians

Jesus
crucified

James

Mark
Matthew

AD 33      AD 40–49      AD 51–59

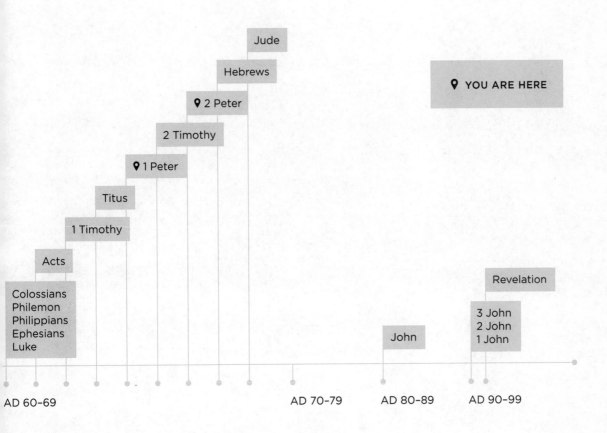

Jude

Hebrews

📍 2 Peter

2 Timothy

📍 1 Peter

Titus

1 Timothy

Acts

Colossians
Philemon
Philippians
Ephesians
Luke

📍 YOU ARE HERE

Revelation

3 John
2 John
1 John

John

AD 60–69

AD 70–79

AD 80–89

AD 90–99

# INTRODUCTION

## GETTING INTO THE EPISTLES OF PETER

Tension. It can flow like an undercurrent beneath our days, a relentless stream that plagues us at home and at work, marring our relationships and disrupting our sleep. The subtle dread, the dart of fear, the dull throb of a headache—tension has a distinctive feel. And it doesn't ease much when we look past our own lives to the world around us. Political tension, fiscal tension, racial tension—it's everywhere. For believers in Christ Jesus, there is also the tension of being hated by the world, misunderstood and maligned. And more often now, we wonder when the world's contempt for us will become outright persecution.

The apostle Peter understood tension because he lived in the midst of it too. In fact, Peter knew from experience what tension feels like—the kind that can rattle your faith at times and make you wonder if walking with the Lord is worth it. And he had many an opportunity to recall Jesus's counsel to would-be disciples: count the cost (see Luke 14:25–33). Peter had learned firsthand that walking with Christ *is* costly—but so totally worth it. That's why he wrote his two epistles, these two letters we find in the New Testament.

### WHO WAS PETER?

We first meet Peter in the Gospels. He was an ordinary fisherman. He had a wife, and we can presume he had children, although we aren't told. Peter's hometown was Bethsaida, a fishing village on the northern shore of the Sea of Galilee.

John's Gospel tells us that when Jesus first saw Peter, he looked at him and said, "You are Simon the son of John. You shall be called . . . Peter," a name that means "rock" (John 1:42). And Luke's Gospel relays that Peter was so amazed by a miracle Jesus performed that he fell down before Jesus and said, "Depart from me, for I am a sinful man, O Lord" (Luke 5:1–11). And Matthew tells us in his Gospel that when Peter heard Jesus say, "Follow me," Peter immediately left his boat and his nets and followed (Matthew 4:18–20). So from these Gospel accounts, we see that Peter was all in with Jesus from the moment he met him.

## Pronunciation Guide

**Balaam:** BAY-lum

**Beor:** BEE-ore

**Bithynia:** bith-IN-ee-a

**Cappadocia:** cap-a-DOE-sha

**Galatia:** gal-A-sha

**Gomorrah:** ga-MORE-a

**Pontus:** PONT-iss

**Silvanus:** sil-VAN-iss

**Simeon:** SIM-e-un

**Sodom:** SOD-um

The Gospels also give us glimpses into Peter's personality. One thing we see is that even though Peter struggled with fear, he wasn't shy when it came to communicating with Jesus. He was often the first one to speak up and ask a question or voice an opinion. And he wasn't afraid to ask for things! At the same time, Peter was a bit too self-confident—that is, until this weakness was exposed when he denied his Lord (Luke 22:54–62). Surely the lessons he learned in that most painful season of his life set the foundation for the emphasis on humility that we find in his letters.

At the Last Supper Jesus had told Peter, "Satan demanded to have you, that he might sift you like wheat, but I have prayed for you that your faith may not fail. And when you have turned again, strengthen your brothers" (Luke 22:31–32 ). Peter did turn back to Jesus, and afterward it was clear that his awful sifting had strengthened his faith, banished his fear, and humbled his heart. Peter lived in a new kind of confidence—even in prison awaiting death, where he wrote his epistles. We too can flourish just as Peter did, and for the same reason: Jesus holds us and will never let go.

### SETTING

Christ followers in Peter's day dealt with a lot of the same problems that we do. They were socially ostracized for refusing to participate in the sins of the Roman culture in which they lived—activities such as throwing criminals to wild beasts for sport while crowds cheered. Another reason Christians were scorned in those days was that they believed that Jesus is the only way to salvation. Their intolerance of other religions and lifestyles infuriated mainstream society. For all these reasons, the threat of persecution hung heavily in the air like humidity on a tropical August day.

The Setting of 1 Peter[1]
c. AD 62–63

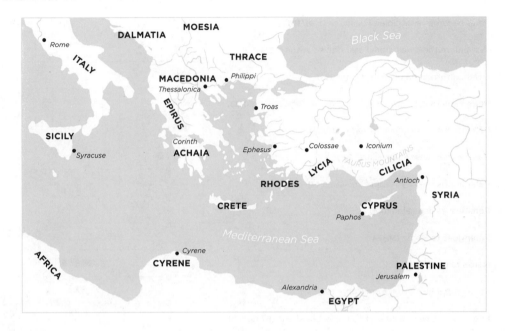

Nero was the emperor of Rome when Peter wrote his letters, and that's important to note because he was writing to people who were living under Roman authority. Nero came to power as a teenager, but because he was so young, he ruled under the authority of his mother for several years before asserting his independence. Nero distrusted many, if not most, people throughout his reign, including his family members, and perhaps for good reason. In those days, the assassination of rulers was a common occurrence, and Nero had numerous enemies. In AD 64, not long after Peter wrote his letters, a raging fire consumed much of the city of Rome. Nero's enemies held Nero personally responsible for the fire. As a way to deflect this bad press, Nero in turn blamed the Christians, which kicked off wide-scale persecution that was characterized by hideous suffering.

This was the world in which the apostle Peter conducted his ministry, and it gives us the background for both of his letters. He wrote the first one a year or two before the great fire in Rome and the second a year or so afterward, when the threat of horrible persecution was closing in. Knowing a bit about Peter's world gives us context for the themes of his letters.

## Events in Peter's Life[2]

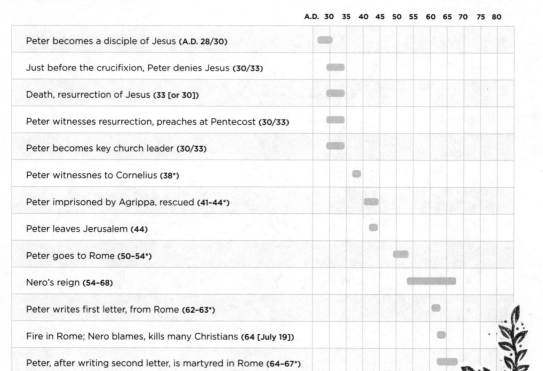

| | A.D. 30 | 35 | 40 | 45 | 50 | 55 | 60 | 65 | 70 | 75 | 80 |
|---|---|---|---|---|---|---|---|---|---|---|---|
| Peter becomes a disciple of Jesus (A.D. 28/30) | ▬ | | | | | | | | | | |
| Just before the crucifixion, Peter denies Jesus (30/33) | ▬ | | | | | | | | | | |
| Death, resurrection of Jesus (33 [or 30]) | ▬ | | | | | | | | | | |
| Peter witnesses resurrection, preaches at Pentecost (30/33) | ▬ | | | | | | | | | | |
| Peter becomes key church leader (30/33) | ▬ | | | | | | | | | | |
| Peter witnessnes to Cornelius (38*) | | ▬ | | | | | | | | | |
| Peter imprisoned by Agrippa, rescued (41-44*) | | | ▬ | | | | | | | | |
| Peter leaves Jerusalem (44) | | | ▬ | | | | | | | | |
| Peter goes to Rome (50-54*) | | | | | ▬ | | | | | | |
| Nero's reign (54-68) | | | | | | ▬▬▬ | | | | | |
| Peter writes first letter, from Rome (62-63*) | | | | | | | ▬ | | | | |
| Fire in Rome; Nero blames, kills many Christians (64 [July 19]) | | | | | | | ▬ | | | | |
| Peter, after writing second letter, is martyred in Rome (64-67*) | | | | | | | ▬ | | | | |

*denotes approximate date

## THEMES

A quick read through Peter's first letter reveals a primary theme—*suffering*. This isn't surprising given the world he lived in. Peter wants to help fellow believers make sense of suffering and to show them how God works through suffering for his glory and the good of his people.

People who are banished, or exiled, from their homes suffer as a result, and *exile* is another significant theme in Peter's first letter. The believers Peter is writing to were most likely living outside of Rome, away from their homes, and trying to make life work in foreign, often hostile, places. Peter uses this circumstance as a picture of how Christians are called to live their lives in this world. In a sense, we are all in exile until we reach our final and permanent home in heaven.

Peter also loves to talk about the *transformative power of God*, something he'd experienced in his early days as a disciple of Jesus. We see this theme very clearly in Peter's second letter, where he emphasizes that God's grace toward us in Christ is the means of our transformation, even when life is hard. As we make our way through Peter's letters, we'll also encounter the theme of *authority*, and we'll learn what it means to submit to the authorities God has placed over us. We'll also learn about the dangers of *false teachers* in the church and how they lead people away from the truth of God's word. And in both letters we will see what *holiness* is and why it matters.

Peter likely wrote his second letter from prison, knowing that he was going to be executed for his faith, and perhaps that's why, in this letter especially, he focuses a good bit on *the last days* and the very last day, when there will be a final judgment. In all this, he emphasizes the hope we are to have in light of *the Lord's sure return*.

## Themes in 1–2 Peter

- suffering
- exile
- God's transforming power
- authority
- warnings about false teachers
- holiness
- the last days
- final judgment
- Christ's sure return

### STUDYING 1–2 PETER

Near the end of his second letter, Peter mentions his fellow apostle Paul and the fact that some of what Paul writes is hard to understand (2 Peter 3:16). Well, as we make our way through Peter's letters, we're going to wish from time to time that we could turn to him and say, "Peter, are you kidding us with that? You are the proverbial pot calling the kettle black." We will encounter a few passages that even the most learned theologians aren't sure about. So we will rely on the Holy Spirit and good Bible study principles to help us.

It's vitally important to say a word here about how to study the epistles, these letters that make up much of the New Testament. Each and every epistle is jam-packed with teaching about salvation in Christ Jesus and

how we're called to live out our faith in day-to-day life. As we read a particular letter, we can expect that certain passages will grip our heart—some new insight about our Lord or a deepening conviction of how we need to mature in our walk with God. These discoveries are exciting, and they draw us deeper into God's word to mine its riches. At the same time, a note of caution is helpful—it's risky to build our understanding of the Lord or of the Christian life on any single passage. In order to understand the epistles and rightly apply them to our lives, there are three things we must take into account: (1) the situation of the author; (2) the original recipients of the letter; and (3) the letter as a whole.

1. *The situation of the author*. When was the author writing, where was he writing from, and why was he writing? Such details are revealed often in the beginning of the letter, sometimes at the end. It's important to mine this information at the very beginning of your study.

2. *The recipients of the letter*. Was the author writing primarily to Jewish believers? Or was the letter directed more toward Gentile converts? Jewish people, Israel, had been set apart as God's special people way back, early on in the Old Testament. When Jesus came centuries later, only some of the Jews believed that he was the long-awaited Messiah. It was these Jewish Christians who were the primary focus of Peter's ministry. Other New Testament letters speak more specifically to Gentile (non-Jewish) believers, who were completely new to the things of God. So why does this matter? It's important because it gives us a *frame of reference*. And this frame of reference matters because it guides our own understanding of the letter and shapes the way we apply it. This is why it's also good to note when a letter is addressed to a particular individual, or when a letter is "circular." A number of the epistles are called "circular letters," which simply means that they were meant to *circulate* among lots of people in more than one place. A circular letter was carried by a courier to the nearest church on the address list, and from there it made its way from church to church.

3. *The letter as a whole*. Think for a minute about the zoom feature in Google Maps. To figure out where we are going, we tend to zoom in close to see a particular street, trying to home in on our destination, but ultimately this street view makes sense only when we zoom back out to see the bigger picture, the entire area surrounding it. This is what it's like to study an epistle in context. We want to zoom in, but in order to understand the close-up, we have to begin with the big picture. So read the entire epistle once through before you begin the study. That's your assignment from this introductory section: read all the way through Peter's first epistle. (We'll read straight through his

second letter before we dive into that part of our study.) And then, at the beginning of each week's lesson, read the entire passage assigned. And then read it again. If you are studying with a group, read the passage once more, aloud, when you gather to discuss the lesson. *Marinating in the Scripture text is the most important part of any Bible study.*

> *Marinating in the Scripture text is the most important part of any Bible study.*

### GROUP STUDY

If you are doing this study as part of a group, you'll want to finish each week's lesson before the group meeting. You can work your way through the study questions all in one sitting or by doing a little bit each day. Don't be discouraged if you don't have sufficient time to answer every question. Just do as much as you can, knowing that the more you do, the more you'll learn. No matter how much of the study you are able to complete each week, the group will benefit simply from your presence, so don't skip the gathering if you can't finish! That being said, group time will be most rewarding for every participant if you have done the lesson in advance.

If you are leading the group, you can download the leader's guide at https://www.lydiabrownback.com/flourish-series.

### INDIVIDUAL STUDY

The study is designed to run for ten weeks, but you can set your own pace if you're studying solo. And you can download the free leader's guide (https://www.lydiabrownback.com/flourish-series) if you'd like some guidance along the way.

## Reading Plan

| | Primary Text | Supplemental Reading |
|---|---|---|
| **Week 1** | 1 Peter 1:1-12 | |
| **Week 2** | 1 Peter 1:13-2:3 | Isaiah 40:6-8 |
| **Week 3** | 1 Peter 2:4-25 | Psalm 118:19-24; Isaiah 28:16; 52:13-53:12; Hosea 1-3 |
| **Week 4** | 1 Peter 3:1-22 | Psalm 34 |
| **Week 5** | 1 Peter 4:1-19 | Malachi 3:1-5 |
| **Week 6** | 1 Peter 5:1-14 | Ezekiel 34:1-16; Luke 22:31-34; John 21:15-18 |
| **Week 7** | 2 Peter 1:1-21 | 1 Corinthians 13 |
| **Week 8** | 2 Peter 2:1-10a | Genesis 6:1-4; 9:1-17; 19:1-38 |
| **Week 9** | 2 Peter 2:10b-22 | Numbers 22:1-38; 31:8, 16 |
| **Week 10** | 2 Peter 3:1-18 | Genesis 6:9-22; 8:13-17 |

# 1 PETER

AS WE BEGIN . . .

Making sense of suffering, most especially the suffering we experience just because we are Christians, is going to be one of our main takeaways from Peter's first letter. Peter wants us to be firmly convinced that our suffering doesn't mean that God has abandoned us or that he expects us to bear hardship in a teeth-gritting sort of way. To the contrary, suffering is an instrument God uses to produce hope in our hearts and to purge out the miserable contamination of sin. And the hope we get isn't just about our final home in heaven—it's for blessings in this life too. We are invited to enjoy God's saving promises here and now through our union with our Savior Jesus Christ.

*In this first letter, Peter seeks to "instruct his readers about who they are in Christ, so that a new way of seeing themselves might both encourage them and motivate their behavior and life choices."*[3]

At the time Peter wrote this letter, there was no government mandate against Christianity although we can be sure that some Christians were persecuted and punished for their beliefs. Even though life-threatening persecution was not widespread at this point, Christians lived under a cloud of suspicion in the Roman world and experienced verbal abuse and various kinds of discrimination.

# A LIVING HOPE

1 PETER 1:1-12

A young woman eats her breakfast and watches fishing vessels glide into the bay and swarm the harbor below. The gold light from the sun, just over the eastern horizon, foretells a warm summer day along the coast of Pontus. A loud shout suddenly interrupts the tranquil morning, and the young woman abandons her meal and dashes with the rest of her household to the street. Such commotion so early in the day is alarming, but anxious concern is soon replaced with joy when the woman and the growing crowd discover its source—a messenger named Silvanus has come bearing a letter from the great apostle Peter! Over the next few days the letter is read and shared among all the local believers, and then they bid a reluctant goodbye to Silvanus, who must carry Peter's message to others, to believers in Galatia, Cappadocia, Asia, and Bithynia.

## 1. GREETINGS (1:1-2)

That whole opening scene is imaginary, of course, but it's a likely picture of how Peter's letter was carried to believers in the five Roman provinces that Peter names in verse 1. We need to linger a bit on verse 1 because the fact that Peter refers to these believers as "elect exiles of the Dispersion" is really important.

First, the people receiving the letter are *exiles*, which means that they are far from home. Now, it could be that Peter used this word in a symbolic sort of way, simply pointing out that our true home is nowhere on earth. In that sense, we are all exiles until we get to heaven. How true this is! It's an important theme in this letter.

At the same time, Peter's original readers were called not just "exiles" but "exiles of the Dispersion." In other words, it's likely that they had been *dispersed*, legally pushed out of Rome and made to live in one of the five outlying provinces named in these opening verses. If that was indeed the case, they would have known the pain of homesickness, and their experience would have helped them understand Peter's deeper meaning—that all believers live in exile until they are home in heaven.

Peter uses one more word to describe these exiles—*elect*. Peter is writing to *elect* exiles. He's reminding them that they've been brought by God into God's family through the life, death, and resurrection of Jesus Christ. God *elected* them—in other words, he *chose* them—to belong.

🕊 Why would Peter's reminder of their secure place in God's family have been so encouraging to these believers who first received his letter?

.................................................................................................

.................................................................................................

.................................................................................................

.................................................................................................

🕊 How does Peter identify himself as he begins the letter?

.................................................................................................

.................................................................................................

.................................................................................................

.................................................................................................

*Apostle* wasn't a job description—it was a calling, specifically a call from the Lord himself. A man couldn't be an apostle unless he'd received this call and unless he'd been with the resurrected Jesus in person. We know from the Gospel accounts that both were true of Peter.

So Peter begins with the standard greeting of his time, identifying first himself and then those to whom he is writing. And then in verse 2 he dives right into some deep theology, basically outlining how God brings his elect people into his family.

To identify people as *elect* is the same as saying they are *saved*, which is a term we are more familiar with. Take a close look at verse 2. How does each person of the Trinity factor into the salvation of God's people?

· Father:

· Son:

· Holy Spirit:

While it's helpful to identify how each person of the Trinity operates, we have to be careful never to separate them. In reality, Father, Son, and Holy Spirit do all things together. It's helpful to think of it this way:

> We who are children of God by grace come to a loving heavenly Father, through the intercession and ongoing heavenly ministry of our sympathetic high priest Jesus Christ, by the helpful ministrations of a caring Holy Spirit. To put it another way, we are not alone in this world. When the breakers of the storms of life crash against our souls, we have a God who watches over us and cares and provides for us.[4]

We can't fully comprehend God in three persons—it's way beyond our ability as human beings. But we do know that our blessings come to us *from* the Father *through* the Son *by* the Spirit.

So with that in mind, let's break down verse 2. Peter tells us here that believers are set apart for salvation. This setting apart happens, first, by God's *foreknowledge*. This doesn't just mean that God knows in advance who will have faith in him. It means he actually oversees and directs the salvation of each and every person. We are saved because God determined that we would be.

*Sanctification* is a theology term that means "set apart." The Holy Spirit sets us apart for God, bringing us into God's family, and then he keeps us safe in that family until we reach heaven. Sometimes we are keenly aware that we've been set apart from the world, but even when we can't detect it in ourselves or in our lives, it is still a spiritual reality.

Peter also tells us in verse 2 that we have been saved for "obedience to Jesus Christ." This obedience might be simply a way of describing the faith we exercise—when we first turn to Jesus for salvation. Or maybe it's more about our commitment to biblical discipleship *after* we have come to Christ. Or maybe Peter had all that in mind.

And then Peter adds that salvation includes being sprinkled with Christ's blood. Writing about blood in the greeting of a letter might seem to us a bit, well, in poor taste. But to the contrary, Peter includes it to spread joy. He's saying that all our sin—past, present, and future—has been taken care of by the blood Jesus shed for us on the cross. That's how we are sprinkled. It's symbolic, but by the power of God it's also very real. The point is, because we've been sprinkled with Christ's blood, we don't have to shed our own blood and die to pay for our sin.

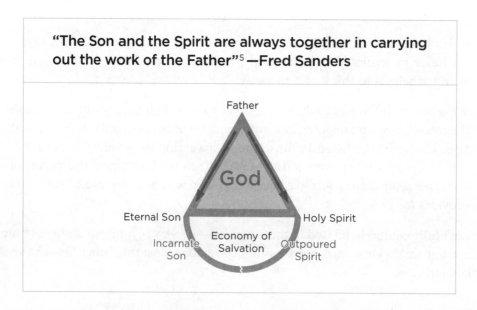

**"The Son and the Spirit are always together in carrying out the work of the Father"[5]—Fred Sanders**

Father

God

Eternal Son

Holy Spirit

Incarnate Son

Economy of Salvation

Outpoured Spirit

✦ How does Peter end his greeting?

......................................................................................................................

......................................................................................................................

......................................................................................................................

......................................................................................................................

## 2. A LIVING HOPE (1:3–5)

✦ As Peter dives into the heart of his letter (v. 3), what is his mood? How do you know?

......................................................................................................................

......................................................................................................................

......................................................................................................................

......................................................................................................................

✦ Which person of the Trinity is Peter's primary focus in verses 3–5, and what actions are attributed to this divine person?

· Verse 3:

......................................................................................................................

......................................................................................................................

......................................................................................................................

· Verse 4:

......................................................................................................................

......................................................................................................................

......................................................................................................................

· Verse 5:

......................................................................................................................

......................................................................................................................

......................................................................................................................

✦ In verse 3 we begin to see the reason for Peter's mood. What underlies God's work on behalf of his people?

...................................................................................................................

...................................................................................................................

...................................................................................................................

...................................................................................................................

✦ According to verse 3, what does God's saving work produce in his people, and how is this linked to Jesus?

...................................................................................................................

...................................................................................................................

...................................................................................................................

...................................................................................................................

In verse 4 Peter builds on why God's people have such great reason for hope, and he mentions the inheritance that awaits believers in heaven. Have you ever inherited something—money or a valuable possession? In the Old Testament, Israelite families were given parcels of the promised land as an inheritance. The passing down of this inherited land from one generation to the next was vitally important, because family identity was linked to property. So if a family lost its land or had no descendant to pass it on to, that family risked losing its unique identity. This backstory is likely why Peter uses the term *inheritance* to describe the hope we get with our salvation.

✦ What three words does Peter use in verse 4 to describe our inheritance?

1. ...............................................................................................................

2. ...............................................................................................................

3. ...............................................................................................................

✦ As you consider those words that describe our spiritual inheritance, what stands out to you most?

---

---

---

---

✦ What aspect of God's nature, in verse 5, guarantees that we will actually get this promised inheritance?

---

---

---

---

Peter writes about "a salvation ready to be revealed in the last time" (v. 5). This isn't a different salvation from the one we're living now; it's simply the fulfillment of it. Everything we enjoy in our walk with God in this life is merely a foretaste of the delights that await us in heaven.

### 3. JOY IN GRIEF (1:6-9)

Peter switches gears in verse 6, bringing his focus on the future back to the present. As he makes this transition, he points to joy. The believers reading his letter are filled with joy because of the blessings that come with salvation. A vital truth is revealed right here: *Rejoicing in our salvation comes through understanding our salvation.*

*Rejoicing in our salvation comes through understanding our salvation.*

✦ What else in verse 6 goes hand in hand?

...........................................................................................................................

...........................................................................................................................

...........................................................................................................................

...........................................................................................................................

✦ What specifics does Peter give in verse 6 about the trials of believers?

...........................................................................................................................

...........................................................................................................................

...........................................................................................................................

...........................................................................................................................

Verse 7 begins with the phrase "so that," linking verses 6 and 7 together. Visualizing it helps us grasp this link:

> . . . now for a little while, if necessary, you have been grieved by various trials, *so that* the tested genuineness of your faith—more precious than gold that perishes though it is tested by fire—may be found to result in praise and glory and honor at the revelation of Jesus Christ.

✦ What does the "so that" tell us about God's purposes in our trials?

...........................................................................................................................

...........................................................................................................................

...........................................................................................................................

...........................................................................................................................

The beauty of gold is evident only after it has been heated so hot in a fire that all the impurities are burned away. It's how precious metals are refined, in other words, how they are made beautiful. This refining imagery is also found in the Old Testament.

✦ Read Job 23:8–10; Psalm 66:10–12; and Proverbs 17:3. What does the refining imagery of precious metals in these passages teach us about the hard things we face?

✦ What, according to Peter in verse 7, is God's intended outcome of our painful refining?

✦ Why does Peter say that faith is more precious than the brightest, shiniest gold?

✦ Peter has some encouraging things to say in verses 8–9 about the believers who are reading his letter. What three characteristics of their saving faith does Peter identify in verse 8?

Peter writes in verses 8–9 that believers reach the outcome of their faith—salvation—through believing and rejoicing. But he certainly doesn't mean that salvation is earned by faith or joy! His point is that as we trust in God, even in the midst of difficulties of all kinds, we are laying hold of the salvation that has already been given to us.

## 4. GLORY REVEALED (1:10–12)

Christians are abundantly privileged because they know in full what God's people in Old Testament times knew only in part.

✦ What did the Spirit of Christ (the Holy Spirit) reveal to the Old Testament prophets?

✦ How, according to verse 12, does the good news of the gospel reach people's minds and hearts?

✦ What do we learn here about angels?

**LET'S TALK**

1. "In this you rejoice," writes Peter in verse 6, speaking of the inheritance that awaits us in heaven. Look back at those opening verses and recap the reasons Peter gives for rejoicing. Would you say that you rejoice as Peter's original readers did? If not, what hinders you?

................................................................

................................................................

................................................................

................................................................

................................................................

................................................................

................................................................

2. Reflect on a season of suffering in your life. How did God bring you through that time, and how did it *refine* you and your faith?

................................................................

................................................................

................................................................

................................................................

................................................................

................................................................

................................................................

................................................................

................................................................

# GROWING UP IN CHRIST

## 1 PETER 1:13-2:3

*Privilege* is a buzzword these days, but the term itself is nothing new. It has to do with benefits. We might say that privileged people are those who enjoy rights and rewards they haven't earned. In that sense, Christians are the most privileged of all. We get all the benefits—forgiveness, provision, joy, and an eternally happy home—that result from the life, death, and resurrection of Jesus Christ. How should we respond to the amazingly privileged status we've acquired through no merit of our own? That's what Peter teaches us in this week's lesson.

## 1. CALLED TO BE HOLY (1:13-16)

Peter begins this new section with a linking word: "Therefore." It ties what he's about to say to what he's just finished saying. He is about to give instructions for how to live in light of the joyous privileges of salvation. We are God's dear children, but with this great privilege comes great responsibility.

✦ How does Peter instruct us, in verse 13, to shape our mind?

........................................................................................................

........................................................................................................

........................................................................................................

........................................................................................................

Peter speaks strongly in verse 13 about our thought life. The original wording of his letter said, "Gird up the loins of your mind." That seems just plain weird to us, doesn't it? But it made sense to his original readers because of the clothes they wore. People in those days wore long robes, and when they had to move quickly, they'd tuck those robes into a belt around their waist to avoid tripping over the flowing fabric. That's what Peter has in mind here. In the same way people back then prepared for fast movement, they had to prepare their minds to stay focused on Christ. And the way they—and we—do this mental girding, this mind preparation, is through controlling their thought life, or, in Peter's words, by "being sober-minded."

✦ Peter uses the term *sober-minded* here in verse 13, and he uses it again two more times later in the letter: 1 Peter 4:7 and 5:8. Look at all three verses where the term is used and then jot down a sentence or two on what it means to be sober-minded.

✦ What step of obedience does Peter prescribe in verse 14? What do you think he means by their "former ignorance"?

✦ What instruction does Peter give in verses 15–16, and what reason does he give for it?

Peter backs up his instructions with the very words of the Lord God himself: "Be holy, for I am holy" (Leviticus 11:44). This tells us something vitally important: even though we live in the New Testament era, the commands of the Old Testament aren't obsolete. The Old Testament commands regulating community life and religious ceremonies were fulfilled by Christ and are no longer valid, but the moral principles behind all those laws—such as the call to be holy—are still as vital today as they were back in Old Testament times.

You might have heard pastors talking about the *imperatives* and the *indicatives* of Scripture. An *imperative* is a definite must, something we are required to do. The Bible is filled with imperatives in both Testaments. This might be depressing were it not for all the indicatives. *Indicatives* in the Bible are declarations of wonderful promises and truths for God's people. Here in verses 13–16, some of these wonders are made clear:

> The grace we experience now is a foretaste of the blessed grace to come (v. 13).

> Jesus will return for us, and we will see him in all his glory (v. 13).

> We are God's children (v. 14).

> As God's children we have been equipped to imitate our heavenly Father (vv. 15–16).

✦ These joyful truths—the indicatives—equip us to live out the instructions—the imperatives—that Peter gives us here. List all the imperatives you see in verses 13–16:

1. ......................................................................................................................

2. ......................................................................................................................

3. ......................................................................................................................

4. ......................................................................................................................

5. ......................................................................................................................

## 2. CHILDREN OF THE HEAVENLY FATHER (1:17–21)

Next Peter reminds us that we know God as our Father because we've been "ransomed" (v. 18), or "redeemed," with the blood of Christ. When we see the word *ransom*, we might think of a suspenseful movie in which a member of a wealthy family gets snatched from bed in the dark of night, blindfolded, and carried away to an abandoned building where he is held until the family agrees to the kidnappers' demand for a ransom of an outrageous sum of money. That's a pretty good picture of what sin does. We were captives, held in bondage to our sin, until Christ paid the ransom that sin demands—not money but blood. Clever kidnap victims might be able to escape their captors, but we could never escape the prison walls of sin. Until we are united by faith to Christ, death and eternal misery await each of us. But Christ paid the ransom. He died in our place on the cross, bleeding out his own blood so we don't have to bleed ours. And he not only freed us from the sin prison; he brought us into his own family so that his Father is now our Father.

What do we learn about our heavenly Father in verse 17, and how is this meant to shape the way we live?

The "fear" Peter has in mind in verse 17 isn't terror. As members of the heavenly family, that kind of fear is over forever. We never need to be afraid of God again. Peter has in mind a reverence for God—a never-ending wow factor that governs all we do. And we honor our heavenly Father by never taking Christ's work for granted.

Sin patterns can run in families, yet even when no patterns are evident, sin is woven into the nature of the DNA we inherited from our very first ancestors, Adam and Eve. In verse 18 Peter says that Christ's ransoming work has actually freed us from bondage to the "futile ways" of worldliness that have been passed down to us. How do the following passages help us understand what Peter means in verse 18 by "futile ways"?

• 2 Kings 17:14–15

.................................................................................

.................................................................................

· Romans 1:21

.................................................................................

.................................................................................

.................................................................................

· Ephesians 4:17–18

.................................................................................

.................................................................................

.................................................................................

Peter says that as we come to know Christ and what he's done for us, we find ourselves increasingly motivated to pursue a holy life. Summarize what Peter teaches in verses 17–21 about both Jesus Christ and God the Father.

| Who the Father Is and What the Father Does | Who Christ Is and What Christ Has Done |
|---|---|
|  |  |

### 3. FAMILY LOVE (1:22-25)

Every single person ransomed by Christ is part of God's family now, which means we have more brothers and sisters than we can count! And we are called to love these family members.

How does living by faith—what Peter calls "obedience to the truth" in verse 22—affect our souls?

From verse 22, identify the characteristics of the love we are to have for our Christian brothers and sisters.

Drawing from the Old Testament prophet Isaiah, Peter uses garden images in verses 23–25 to deepen our understanding of our salvation. (Take a moment to read Isaiah 40:6–8, which Peter is quoting.) What does Peter's garden illustration reveal about how we are saved?

## 4. GROWING UP (2:1–3)

Peter didn't divide his letter into chapters. That happened much later. That's why when we read the beginning of chapter 2, it seems to belong with chapter 1. Originally all these sections made up one long, flowing letter.

What five sins are believers to "put away," to crush out of their lives and hearts, in 2:1? What do these particular sins have in common?

The first word of chapter 2, "So" (or "Therefore" in some translations), connects Peter's instructions here to the end of chapter 1. As you scan the final verses of chapter 1, note why believers are called to put away the particular sins named in 2:1.

How does Peter's image of a newborn baby help you understand the process of growing up in the faith? What is Peter conveying through this image?

What condition—the *if* clause—does Peter attach in verse 3 to the call to grow up? Why might Peter have chosen to add this condition here?

.........................................................................................................................

.........................................................................................................................

.........................................................................................................................

.........................................................................................................................

### LET'S TALK

1. Peter indicates that a vital way we grow up in our faith is by governing our thought life (1:13). He calls us to prepare our minds for action and be sober-minded. (You might also want to look at Romans 12:2; Ephesians 4:20–23; and Colossians 3:2.) In light of the importance Scripture places on our thoughts, discuss how our emotions factor in. When can emotions help our walk with God, and when might they be a hindrance?

.........................................................................................................................

.........................................................................................................................

.........................................................................................................................

.........................................................................................................................

.........................................................................................................................

.........................................................................................................................

.........................................................................................................................

2. Our belonging in the family of God is meant to bring about a deep love for the rest of the family, which includes all believers. What does such love look like, according to 1:22 and 2:1? As you discuss Peter's call to love, include aspects that you would like to grow in.

_____

_____

_____

_____

_____

_____

_____

_____

# A SPIRITUAL HOUSE

1 PETER 2:4-25

Early evening just after the sun goes down is an ideal time to take a walk through just about any town. Houses are well lit, and glimpses of family life are visible from the sidewalk. Many of us are passionate about houses—architecture, style, furnishings—and a primary reason is surely the base they provide for home. Comfort, security, acceptance—it's how we envision home and what we yearn to create in our own lives and for the people we love. Well, we may or may not enjoy that sort of home in day-to-day life, but once we're in Christ, we've got the best home of all. Peter teaches that each one of us is actually part of a house—a spiritual house—and he calls us to live as fruitful members of this home.

## 1. LIVING STONES (2:4-8)

We can't always see our spiritual progress, but if we belong to Christ, we can be sure it's happening. Once we are united to Christ by faith, our spiritual maturity is guaranteed. It's a process that theologians call "sanctification," and as part of that process, our lives are spiritually bound up with the lives of all believers. To help us understand this, Peter describes the process as a house being built.

*Sanctification is the process by which the Holy Spirit transforms believers to become more and more like Jesus Christ.*

✤ According to verse 4, how are believers built up as a spiritual house?

................................................................

................................................................

................................................................

................................................................

✤ Jesus is called "a living stone" in verse 4. What else does Peter say about Jesus in this verse?

................................................................

................................................................

................................................................

We are being built up as a spiritual house, and in this house, we live as "a holy priest-hood" and offer "spiritual sacrifices" (v. 5). We need the Old Testament in order to make sense of this. In Old Testament times, people couldn't just worship God anywhere they felt like worshiping. Those who wanted to draw near to God had to go to the temple. It was the only true spiritual house in those days. The temple is where God's people went to worship and pray and have fellowship. It's also where the priests interceded for God's people by offering sacrifices of animals to pay for sins—a bloody, messy, smelly business. One part of the temple, the Most Holy Place, was so sacred that only the high priest was allowed in, and he could enter this most sacred space only one day each year in order to sprinkle lamb's blood to atone for people's sins. So that's a bit of the backstory. When Christ came, all this changed.

✤ Look again at verses 4–5. How does our coming to Christ change that Old Testament system of temple and priests and sacrifices?

· Temple:

................................................................

................................................................

................................................................

· Priesthood:

.....................................................................................................................................

.....................................................................................................................................

.....................................................................................................................................

· Sacrifices:

.....................................................................................................................................

.....................................................................................................................................

.....................................................................................................................................

✦ In our new role as priests, we are called to offer what Peter calls "spiritual sacrifices" (v. 5). What do the following passages teach us about the nature of these sacrifices?

· Romans 12:1–2

.....................................................................................................................................

.....................................................................................................................................

.....................................................................................................................................

· Hebrews 13:15–16

.....................................................................................................................................

.....................................................................................................................................

.....................................................................................................................................

Now we get to the heart of Peter's teaching in this section. The spiritual house we are part of is set firmly on Christ, whom Peter calls a "living stone" (v. 4). It's a strange image, isn't it? How can a stone be alive? It can't, of course. Peter is drawing from something in the Old Testament here, which he then shows us: Jesus is the *cornerstone* of this spiritual building. A cornerstone is the first piece of masonry set into the foundation of a new structure, and it's the stone that all the other stones are set on and around. Later, the cornerstone might be engraved with the building's completion date or the

name of the architect or another important person. Peter draws all this architectural imagery from the Old Testament.

Peter goes back to the Old Testament because he wants his readers to understand that Christ has always been the foundation of God's people, even long before he was born into this world. Peter makes his case from Isaiah 8:14 and 28:16 and from Psalm 118:22, which recounts a time in history when some builders rejected a particular stone for some unknown reason. This long-ago incident became symbolic for rejecting the Messiah.

Understanding all this symbolism is a challenge for us, so let's step back to see the big picture here. In verses 6–8 Peter uses the Old Testament to show a vital contrast between two groups of people. Identify these two groups and what happens to each.

· Group 1:

_____

_____

_____

· Group 2:

_____

_____

_____

Peter ends the cornerstone lesson on a somber note. Those who reject Christ as their foundation fulfill their own destiny. In other words, their rejection of Christ proves they are not among the elect.

As we saw in Week 1, the elect are those whom God has saved by faith and united to his Son, Jesus. And we mustn't think for a minute that God shuts out anyone who wants to be saved! We see here in verse 8 that those who "disobey the word"—in other words, those who refuse to embrace Christ—are willing participants in their destiny. When we encounter hard things like this, we often need to stop and pray for the Spirit's help to understand and accept what Scripture shows us.

## 2. OUR IDENTITY (2:9-10)

Unlike those who refuse Christ and stumble, believers walk securely in a glorious four-part identity.

✦ List each part of our identity from verse 9:

1. ................................................................................................................

2. ................................................................................................................

3. ................................................................................................................

4. ................................................................................................................

✦ For what purpose have we been given this identity?

................................................................................................................

................................................................................................................

................................................................................................................

................................................................................................................

In verse 10, Peter once again draws from the Old Testament—this time, from the prophet Hosea. Long ago, God directed Hosea to marry a loose woman who would cheat on him with other lovers and break his heart. During this tumultuous season, the couple had children who were given names to reflect their troubled marriage. A daughter was named "No Mercy" and a son was named "Not My People." All this was meant to expose how God's people were cheating on him with idols and cutting themselves off from their divine husband. But God never leaves his people, even when they leave him. So to demonstrate his heart for his people, God instructed the grief-stricken prophet to go after his cheating wife and to do whatever was necessary to bring her home. This is exactly what God has done for us. He has brought us home by means of his Son, showering us with mercy and making us his people forever.

How does this reminder from Hosea encourage us to live out our Christian identity as Peter defined it for us in verse 9?

### 3. AN URGENT MATTER (2:11–12)

With mercy now fresh in our minds, Peter makes an urgent appeal in verses 11 and 12. He roots his appeal in our status—we are exiles, pilgrims on a journey to a heavenly homeland. Living with this status always in mind enables us to keep our day-to-day lives in perspective. In other words, life here might be hard, but it's so very brief in light of eternity and the joys that await us when our journey is done.

What instruction does Peter give about fleshly passions in verse 11?

What do you think Peter means by "passions of the flesh"? If you aren't sure, you might want to take a look at Galatians 5:19–21 and James 4:1–4.

In the Old Testament, the term *Gentile* was used for non-Jewish people, those outside of Israel, God's family. Once Christ came, God's family expanded to include people from every nation and race who trusted Christ as their Savior, and the word *Gentile* was then

used to indicate anyone outside the Christian faith. So in verse 12 Peter uses the word "Gentiles" the way we use the words "unbelievers" or "non-Christians."

✦ How are we called to live before unbelievers, and for what purpose?

..............................................................................................

..............................................................................................

..............................................................................................

..............................................................................................

After reading verses 11 and 12, you are likely wondering what Peter meant by "the day of visitation." We don't need to get hung up on trying to nail down his exact meaning, because we simply can't be sure. He might have been thinking about a particular day when skeptical unbelievers are changed and believe, or he might have in mind the day when Christ will return to gather all his people and take them home to heaven forever.

## 4. WHO'S IN CHARGE? (2:13-17)

These verses are crammed full of instructions for a particular aspect of holy living. If we had to come up with just one word to summarize this section, a good choice would be *authority*.

✦ Read verses 13–14, then note below the three ways that Peter shapes our view of governing authorities.

· God's hand in government:

..............................................................................................

..............................................................................................

..............................................................................................

· Christians' response to government:

..............................................................................................

..............................................................................................

..............................................................................................

· The purpose of government:

&#10022; What do we learn about God in verse 15?

Peter calls us in verse 16 to live as free people and to use our freedom to serve God rather than ourselves. This is one of our greatest challenges when it comes to submitting to authority—bowing to the lordship of Christ when it might mean giving up a dream we cherish or a pleasure we enjoy.

&#10022; What does it mean to "live as people who are free" (v. 16)? To formulate your answer, you might want to take a look at John 8:31–36.

&#10022; In verse 17, Peter uses the word *honor*, or *respect*, two times. *Love* is used once, as is *fear*, which doesn't mean "terror" here. It means reverence and awe. Taken altogether, what do these terms convey about the kind of submission to authority that God wants from his people?

## 5. SUFFERING SERVANTS (2:18-25)

Peter is still on the topic of authority, and here he turns his focus specifically to servants, or slaves. This is hard for us to read, right? Most of us are well aware of the evils of slavery. Right here we need to clarify that the slavery in Peter's day was often somewhat voluntary, serving as a way to pay off debt. The Bible soundly condemns any sort of slavery that involves man stealing (see Exodus 21:16). Even so, servants and slaves in Peter's day were often mistreated, yet he instructs them to endure. Peter is not upholding abuse here. He is actually going against the culture by directly addressing servants and slaves. By including them in his instructions, he's placing them alongside every other believer in terms of status and dignity.

✦ Why is a servant's willingness to endure unjust suffering "a gracious thing" (v. 19) in God's eyes?

We might wonder why Peter doesn't address the unjust masters here as well, but we mustn't infer from this silence that he condones abuse or injustice. Mistreating any human being is grievous in God's eyes, as of course Peter would agree. The reason he doesn't address those sinful abusers here is that he's making a completely different point. Peter is actually directing us to Christ, the servant who suffered more than any other. Perhaps make some time this week to read about Jesus as the suffering servant in Isaiah 52:13–53:12.

> *Behold, my servant shall act wisely;*
> *he shall be high and lifted up,*
> *and shall be exalted. (Isaiah 52:13)*

✢ List all the things Peter says about Christ, the ultimate suffering servant, in verses 21–24.

  · v. 21

  ......................................................................................

  ......................................................................................

  ......................................................................................

  · v. 22

  ......................................................................................

  ......................................................................................

  ......................................................................................

  · v. 23

  ......................................................................................

  ......................................................................................

  ......................................................................................

  · v. 24

  ......................................................................................

  ......................................................................................

  ......................................................................................

✢ Look again at verses 24–25. As you consider these verses along with all Peter's words about Christ in this section, how are we to best understand the healing he mentions in verse 24?

......................................................................................

......................................................................................

......................................................................................................................................

......................................................................................................................................

✦ Peter uses two titles for Christ in verse 25, both of which describe aspects of Christ's character. How do these titles equip us to carry out Peter's instructions about suffering unjustly?

......................................................................................................................................

......................................................................................................................................

......................................................................................................................................

......................................................................................................................................

✦ Jesus holds us close to his heart, no matter what trials we face. Peter has shown us quite a lot about our Lord this week. What about Jesus has struck you most as you've worked through the lesson?

......................................................................................................................................

......................................................................................................................................

......................................................................................................................................

......................................................................................................................................

## LET'S TALK

1. As Christians, we are part of a chosen race, a royal priesthood, and a holy nation, and we belong to God. That is the identity of each of us in Christ, yet we are prone to identify ourselves by what we have or what we do—"I'm a mom," or "I'm a math teacher." Do you naturally define yourself by who you are in Christ? If you more readily define yourself by what you do in day-to-day life or by something you have, why do you think you default here? How can Peter's identity categories—chosen race, royal priesthood, and holy nation—reshape how we see ourselves and impact how we live? Try to set out a practical application.

......................................................................................................................................

......................................................................................................................................

........................................................................................................................

........................................................................................................................

........................................................................................................................

........................................................................................................................

........................................................................................................................

........................................................................................................................

2. Peter touched on authority figures this week, from governments to servant masters. What people or institutions has God placed over you in your daily life? Do you struggle with submitting to any of these authorities? If so, which ones? Discuss your struggle— when it tends to occur and why.

........................................................................................................................

........................................................................................................................

........................................................................................................................

........................................................................................................................

........................................................................................................................

........................................................................................................................

........................................................................................................................

# LIVING IN LOVE

## 1 PETER 3:1-22

Peter has been calling us to submit to the authorities God places over us, even when those authorities mistreat us. But this isn't about earning favor with God or with the people around us. It's about love: "To this you have been called, because Christ also suffered for you, leaving you an example, so that you might follow in his steps" (1 Peter 2:21). Christ submitted to unjust treatment for our sake. So are we willing to do likewise if it's an opportunity to glorify God by demonstrating the love of Christ to others? Well, that depends, right? In all honesty, we'd have to say we're open to suffering *some*, depending on the circumstances, but, we say, there's a limit. That's why Peter ties up his call with another huge motivation—great blessing. Christ was victorious over suffering and injustice, and we get to share in the joys of that victory.

## 1. A WORD FOR WIVES (3:1-7)

Marriage is a gift from God, and when it's lived out as God intended, both husband and wife are richly blessed. Such marriages are meant to be a real-life illustration of the bond between Christ and his people.

✦ What reason for wifely submission does Peter give in verse 1?

✤ When it comes to submission, Peter specifically mentions a wife's conduct. How does he describe it in verse 2?

........................................................................

........................................................................

........................................................................

## A Wife's Submission to Her Husband

| What It Is | What It Isn't |
| --- | --- |
| • Helping | • Giving up your identity |
| • Respecting | • Tolerating abuse |
| • Honoring | • Participating in sin |
| • Encouraging | • Squashing your views |
| • Deferring | • Having no voice |

It is vitally important here to emphasize that Peter is in no way advocating that a wife submit to abuse! Spousal abuse was frowned upon in Peter's day—not only among Christians but also in society at large. So then, as now, evidence of a mistreated wife would most certainly impede rather than help gospel witness. Peter's primary aim here is to guide a believing wife not to pressure an unbelieving husband to convert to the Christian faith but rather to wisely win him to it.

✤ Peter describes the type of adornment that God delights in. How exactly can the character quality of a gentle and quiet spirit make a woman beautiful?

........................................................................

........................................................................

.................................................................................................................

.................................................................................................................

✦ How do the following passages shed light on what Peter means by a "gentle and quiet spirit" (v. 4)?

· Psalm 131:1–3

.................................................................................................................

.................................................................................................................

.................................................................................................................

· Proverbs 21:9; 29:11

.................................................................................................................

.................................................................................................................

.................................................................................................................

· Galatians 5:22–23

.................................................................................................................

.................................................................................................................

.................................................................................................................

· 1 Timothy 2:9–10

.................................................................................................................

.................................................................................................................

.................................................................................................................

In verse 3 Peter also advises wives about the wisdom of an understated appearance. He cautions about flashy jewelry and hairstyles, but we mustn't assume that he's prohibiting any type of outward adornment whatsoever. His point is that a woman's heart is

revealed in how she presents herself. Does her appearance reflect a heart that trusts in the Lord and finds security in him, or is she relying on wealth or beauty to gain favor and approval?

The point Peter is making is that a wife's submitting to her husband's leadership is another facet of her adornment. Peter makes this case from the Old Testament with Sarah, the wife of the patriarch Abraham. Peter tells us that Sarah obeyed Abraham and called him "lord." This sounds almost blasphemous to our ears, but the title *lord* was used to show respect, the way we call someone Mr. or Mrs. or ma'am or sir. We don't know if Peter had in mind a particular episode from Sarah's life here. He certainly might have, but it's just as likely that he has a bigger picture in view—their overall marriage, which we see in the book of Genesis. Peter could have drawn from any number of Old Testament wives to make his point here, but he chose Sarah likely because she had been admired by God's people right up through Peter's day.

Even so, there *is* a particular episode in Genesis that Peter might be referencing. It's when Sarah overheard the Lord repeat a longtime promise he'd made to Abraham: "I will surely return to you about this time next year, and Sarah your wife shall have a son" (Genesis 18:10). Sarah had all but given up on God's promise of conceiving a baby because she and Abraham had grown old. Hearing it again all these years later made her laugh and say to herself, "After I am worn out, and *my lord* is old, shall I have pleasure?" God heard her laugh and said, "Is anything too hard for the Lord?" (Gen. 18:12–14).

So you might be wondering at this point what on earth Sarah has to do with Peter's discussion about adornment and submission. Pastor David Helm helps us here:

> The laughter of Sarah can still be heard . . . today. The voices of many women who hear these words on submission are likely to exclaim, "You have got to be kidding me. That's absurd. God will keep his promises to me? He will keep me safe in this relationship?" And Peter says, "Yes. God can be trusted." Women who give themselves to this pattern of life, though it is "frightening" (v. 6), will be those whom God meets in their hour of need. Those who entrust themselves to God will find that he will keep his word to them. And what was his promised word? "You have been born again to a living hope, and you shall receive an inheritance that is imperishable, undefiled, and unfading" (see 1:3, 4).[6]

✦ Peter then turns his attention to husbands. How, according to Peter, are husbands to show understanding to their wife? What will happen if a husband refuses?

........................................................................................................................

........................................................................................................................

........................................................................................................................

........................................................................................................................

## 2. GODLINESS IN EVERYDAY LIFE (3:8–17)

Peter broadens his instructions at this point to include all believers, not just wives and husbands. He longs for believers to live in such a way that all are built up, and he also cares about how Christians are viewed by unbelievers.

✦ List the five traits from verse 8 that every believer is meant to practice in everyday life:

1. ....................................................................................................................

2. ....................................................................................................................

3. ....................................................................................................................

4. ....................................................................................................................

5. ....................................................................................................................

✦ Finding these five traits here might have surprised Peter's original readers. That's because, in those days, these traits were typically thought of only in the context of ordinary, everyday family life—and isn't Peter's letter about more weighty spiritual matters? In light of that perspective, why do you think Peter chose to list these traits here in the context of the Christian community?

........................................................................................................................

........................................................................................................................

........................................................................................................................

........................................................................................................................

✤ Whenever we see repeated words or instructions in one of these New Testament letters, we need to take special notice, because the repetition signals that we are hitting on a key theme or concern. That's the case with verse 9. How is verse 9 similar to what Peter wrote in 2:19–21?

.......................................................................................................................

.......................................................................................................................

.......................................................................................................................

In Peter's day, it was unthinkable not to stand up for your rights. In fact, those who didn't were perceived as weak and sometimes openly scorned. Humility was not a virtue in Roman society, and it was considered shameful to fail to uphold your honor when it was trampled on. Perhaps that's why Peter turns, in verses 10–12, to Psalm 34 to motivate his readers to lay down their rights as an act of love. This isn't the only time we see reflections of Psalm 34 in Peter's first letter. In fact, the overall message of Psalm 34 was likely a significant influence on Peter's writing.

✤ Read Psalm 34. What in that psalm is reflected in Peter's overall outlook on life's hard things?

.......................................................................................................................

.......................................................................................................................

.......................................................................................................................

✤ We certainly avoid much trouble in life by walking a righteous path, Peter writes in verse 13, but even when we do walk in righteousness—and sometimes especially when we do—it can prove costly and lead to suffering. What promise does Peter hold out to righteous sufferers in verse 14?

.......................................................................................................................

.......................................................................................................................

..................................................................................................

..................................................................................................

God takes note of the harm done to his people, and he is vitally in tune with their suffering. Sometimes he provides a dramatic deliverance. Other times, he strengthens us to persevere in the midst of hardship. Either way, we can count on God's care when we suffer for Christ's sake.

✝ Peter exhorts believers not to fear those who persecute them. According to verse 15, what are we to do instead, and how are we to do it?

..................................................................................................

..................................................................................................

..................................................................................................

..................................................................................................

✝ Read Luke 22:31–34, 54–62. Where can you detect echoes of this incident from Peter's past in what Peter writes here in this section of his letter?

..................................................................................................

..................................................................................................

..................................................................................................

..................................................................................................

✝ Peter says that we should be readily prepared to talk about the gospel and our faith in Christ and that we should do so with "gentleness and respect" (v. 15). How does Colossians 4:5–6 refine our understanding of Peter's instructions here?

..................................................................................................

..................................................................................................

..................................................................................................

..................................................................................................

Peter stresses the importance of a clear conscience when it comes to sharing our faith. He's basically saying, "Don't be a hypocrite." Peter certainly isn't implying that we must have our spiritual act totally together before we tell others about the gospel. After all, who among us does? His point is that there mustn't be hidden sinful secrets in our lives that, if exposed, would mar the reputation of Jesus, whose name we bear.

The same principle applies when it comes to trust. Do we know the Lord as our security—really? Or do we profess to trust him while leaning on something or someone else for safety and comfort? As someone wisely said, we can't genuinely point others to Christ as Savior if we are defaulting elsewhere.

What comparison does Peter make in verse 17, and how does God factor in?

## 3. CHRIST OUR HOPE (3:18–22)

If this passage baffles you, you're not alone. Even the great Reformer Martin Luther said, "A wonderful text is this, and a more obscure passage perhaps than any other in the Testament. . . . I cannot understand and I cannot explain it. And there has been no one who has explained it."[7] Well, we're going to work our way through it to grasp the big picture.

Peter begins by focusing us on the suffering of Christ. When we suffer for our faith—when we experience injustice or mistreatment—our perspective on our suffering changes when we keep Christ's suffering in the forefront of our mind.

According to verse 18, why did Christ suffer?

Jesus was "put to death in the flesh but made alive in the spirit" (v. 18). In other words, his suffering on the cross resulted in his death, but then he was raised from the dead. The next verse is where we have some mystery. In verse 19 Peter tells us that Jesus preached to "the spirits in prison." Peter tells us that these "spirits" had at one time disobeyed God, and then he brings in Noah and the ark from the first book in the Old Testament, Genesis.

Some Bible teachers think that these imprisoned spirits were fallen angels. Others believe that the spirits were dead people that Christ met with in the short time between his death and resurrection to share the gospel. And still others think that the spirits were actually wicked people in Noah's day, and that Christ preached through the mouth of Noah in order to save these wicked people from judgment in the coming flood.

We do not know exactly what Peter had in mind here. But his reference to Noah's ark and the flood does help us understand something about Christian baptism. The flood of Noah's day was God's judgment on sin. At that time, the wicked were judged by going down into water. Only a few were saved by being brought up out of the water, safe in the ark. So the sacrament of baptism actually reflects what happened to those few in the ark. In baptism, we are symbolically saved from the waters of judgment and raised to new life—all because Jesus Christ went down in our place and then was raised up from death to the highest place in heaven. So when Peter says that baptism "saves" us (v. 21), he isn't saying that baptism is required for salvation. He's simply saying that participating in baptism is a sign of our faith in the one who *does* save us—Jesus.

As Peter draws the connection between the flood in Noah's day and baptism, he says that baptism is "an appeal to God for a good conscience" (v. 21). Based on his teaching here, what actually clears our conscience?

......................................................................................................................................................

......................................................................................................................................................

......................................................................................................................................................

......................................................................................................................................................

Whew! We've almost made it through this most challenging section of the letter. And here's the good news: we don't have to figure out who those spirits in prison were or what exactly Jesus preached or to whom. If we stand back now from all these details, we can see the big picture.

✦ What is Christ doing at the beginning of this section, in verse 18?

✦ What is Christ doing at the end of this section, in verse 22?

Can you see the big picture? Yes, Jesus suffered and died for his people, but he was raised from the dead, and he ascended back to heaven. Christ triumphed over suffering! And he did it for us.

Peter wants us to keep our Lord's suffering in view as we face the pain of injustice or mistreatment, but it's just as vital to remember the outcome. Christ's story ended in triumph, and that's why we can be confident that our own suffering isn't the end of our story either.

### LET'S TALK

1. Peter's words to wives about submission can be hard to hear and even harder to live out. Think about a godly marriage you observe firsthand, one that seeks to live by biblical principles. It could be the marriage of friends or your parents or your pastor. Maybe it's your very own marriage!

So far as you know, how does submission factor in to this marriage, and what blessings have you observed (or experienced) as a result?

2. Peter wants us to get that Christ's victory over suffering is meant to give us hope in the midst of our own suffering and actually change the way we live. Look at Romans 6:3–4 and Ephesians 2:4–7 and explain how Christ's victory changes us practically. How does it encourage you personally in a current trial or struggle?

# THE GOD WHO PURIFIES

## 1 PETER 4:1-19

Suffering—we've encountered it every week in our study so far, particularly the suffering of our Lord Jesus Christ. We find suffering again in chapter 4, but Peter's emphasis here is a bit different. Up till now, Peter has highlighted Christ's suffering as a way to encourage us to persevere in our own difficulties, most especially the trials we suffer because of our faith. Here in chapter 4 Peter takes us one step further, calling us to see our suffering as part and parcel of our identity as Christians. Our natural tendency is to resist suffering, right? But when we get a fuller grasp of God's purpose for it, our resistance softens. That's where Peter takes us this week. He also calls us to love others in concrete, practical ways, no matter our circumstances. The best way to gear up for this week's study is with prayer. Ask God for enabling grace to hear with your heart and embrace what you hear.

## 1. LIVING FORWARD (4:1-6)

Once again Peter anchors us in Jesus Christ as he guides us to deal with our suffering. Here, he calls us to "arm" ourselves with the mindset Jesus had toward his suffering— a willingness to accept it. When we allow our thinking to be shaped by Jesus, we aren't as likely to panic when suffering comes and to do something (anything!) desperate to duck it. That's what Peter is getting at when he writes, "whoever has suffered in the flesh has ceased from sin" (v. 1). If we are willing to suffer for our faith, we won't seek to escape it by some unwise or sinful means.

How does Peter clarify this godly mindset in verse 2?

.................................................................................

.................................................................................

.................................................................................

.................................................................................

Peter says that unbelievers ("the Gentiles") want to live in a certain way—they desire it and pursue it. When you look at Peter's list of vices in verse 3, what do you think characterizes those who live this way? (Hint: the opposite virtues are identified in verse 7.)

.................................................................................

.................................................................................

.................................................................................

.................................................................................

Why do you think unbelievers fervently pursue destructive overindulgence? Provide an answer from each of the passages below.

· Romans 1:28–31

.................................................................................

.................................................................................

.................................................................................

· 1 Corinthians 10:7; 12:2

.................................................................................

.................................................................................

.................................................................................

· Ephesians 4:17–19

.................................................................................................................

.................................................................................................................

.................................................................................................................

✧ Peter says that unbelievers are surprised when Christians stop sinfully indulging themselves. Apart from Christ, most people live in pursuit of pleasure, seeking to gratify every physical craving, and they "malign," or spitefully scorn, those who no longer participate (v. 4). Unrepentant sinners hate those who seek to live in God's ways because it makes them feel guilty. What big-picture perspective does Peter hold out in verse 5 to strengthen us for these situations?

.................................................................................................................

.................................................................................................................

.................................................................................................................

.................................................................................................................

This section ends on another one of those "Peter, what are you talking about?" notes when he tells us in verse 6 that the gospel was preached to "those who are dead." His meaning is really quite simple: he has in mind people who were alive when they heard the gospel but have since died. The basic point of this difficult verse is that God is going to judge everyone, and those who wish to be spared God's judgment must heed the good news of salvation in Jesus in this lifetime, *before* they die.

## 2. EARNEST LOVE (4:7–11)

"The end of all things is at hand," Peter writes (v. 7). Can you sense the urgency here? It's meant to shape how we live our day-to-day lives. The day of judgment could arrive at any time. This era, "the end of all things" or "the last days" (Heb. 1:1–2), began at the time of Christ. His coming to earth to die for our sins was the turning point of history for the whole world. We have been in the time of the end ever since Jesus rose from the dead and ascended back to the Father in heaven.

What two character traits are to define believers in their daily lives, and how are these traits a direct contrast to what Peter reveals about unbelievers in verse 3?

Peter makes a clear link between self-discipline and prayer at the end of verse 7. How do the following passages explain why Peter makes this link?

· Matthew 26:36–41

· Luke 21:34–36

Peter affirms what we see all through Scripture—love is meant to be our top priority (v. 8). How does he characterize the sort of love believers are to have for one another?

Love covers sins, Peter adds here, but he doesn't mean that love erases sin or the pain it causes. Peter's point is that love wants to see the best in others and interprets their circumstances in a favorable light whenever possible. And even when it's not possible, love takes no pleasure in harping on someone's sin or discussing it with others.

✦ How is love practically lived out in verse 9, and how are we to do it?

.................................................................................................

.................................................................................................

.................................................................................................

.................................................................................................

✦ Love is also worked out practically when we use our spiritual gifts, Peter writes in verses 10–11. What two categories of gifts does Peter mention here, and what condition does he apply to each?

| | Gift Category | Condition |
|---|---|---|
| 1. | | |
| 2. | | |

✢ A variety of spiritual gifts falls under these two general categories. The first category tends to be more visible than the second, but both are equally important. Whatever our gifting, God administers his grace through us to others when we put our spiritual gifts to work. What is the overarching reason supplied here for why we are given spiritual gifts?

.......................................................................................................................

.......................................................................................................................

.......................................................................................................................

.......................................................................................................................

Verse 11 ends with a doxology: "To him belong glory and dominion forever and ever. Amen." A doxology is an expression of praise to God and often appears at the end of a letter or a section of a letter. Peter's doxology here puts a glorious finish on our motivation for Christian living.

> *To him belong glory and dominion*
> *forever and ever. Amen. (1 Peter 4:11)*

## 3. FIERY TRIALS (4:12-19)

Suffering—Peter returns to this subject as he begins this section of his letter. He clearly desires that his readers view suffering—fiery trials (v. 12)—from the perspective of their eternal destiny with a loving God.

✢ According to verse 12, how should we view the trials we face, and what does such a view indicate about our trials?

.......................................................................................................................

.......................................................................................................................

.......................................................................................................................

.......................................................................................................................

✝ Peter classifies trials here as "fiery" (v. 12). He might have been thinking of the Old Testament prophet Malachi's description of how God refines his people in order to spare them his terrifying judgment. Read Malachi 3:1–5 and Hebrews 12:7–11. How do these passages help us understand a bit more about why Peter might have described our trials as "fiery"?

_____

_____

_____

_____

✝ How does Peter direct us to respond to trials in verses 13–14, and why?

_____

_____

_____

_____

A day will come—the day when Christ returns to earth, revealing his glory—when we will actually rejoice at the sufferings we've gone through. But the blessings that come to us as a result of suffering aren't all future oriented. Peter tells us that even now, when we suffer because we are Christians, we receive a special blessing: the Holy Spirit rests on us in some special way.

✝ Identify the two types of suffering Peter outlines in verses 15–16.

1. _____

2. _____

It's kind of surprising that Peter includes meddling on his sin list in verse 15. What is meddling? It's basically involving ourselves in something that's none of our business. Meddling just doesn't seem quite as bad as the other qualities he names—murder, stealing, and doing evil—but as we think about meddling in terms of how it can impact our Christian reputation, we get an idea of why Peter includes it here. Busybodies,

know-it-alls, and those who force themselves uninvited into people's problems don't reflect the gentle, respectful way Jesus approached people during his ministry, and, as Peter has been saying throughout this section, God's people are to seek to glorify God in all they do (vv. 11, 16).

Peter is quick to point out that there's no shame in suffering because we bear the name of Christ: "If anyone suffers as a Christian, let him not be ashamed. . . . For it is time for judgment to begin at the household of God" (vv. 16–17). Peter's words about judgment in God's household take us back again to the prophet Malachi, where we learn how God purifies his people as metals are refined by fire (Malachi 3:1–5). Another Old Testament prophet, Ezekiel, also had a vision of God's judgment on his wayward people. In this vision, in Ezekiel 9:1–6, God's judgment begins with the religious leaders because they were the ones most responsible for leading God's people into sin. But it was a painful judgment across the whole spectrum of his people. Even so, God's intention in this severe judgment was to purify, to purge out corrupting influences. In other words, it was meant for long-term good, not destruction. This purifying work is the sort of judgment Peter has in mind here.

+ In light of that background, how would you answer Peter's question at the end of verse 17?

......................................................................................................................................

......................................................................................................................................

......................................................................................................................................

......................................................................................................................................

Peter then reinforces his point with a verse from Proverbs 11:31, which he quotes in verse 18:

> If the righteous is scarcely saved,
>     what will become of the ungodly and the sinner?

Peter isn't saying that believers just barely make it to heaven; his point is that painful purifying definitely plays a part in how God prepares us to live in our eternal home. God's fire destroys the wicked, but for those who belong to him through Christ, that same fire just burns away the lingering muck and mire caused by sin.

In verse 19 Peter summarizes everything he's been saying about suffering. In light of all he has written, what is our two-part response, and why is it a safe response for us?

1. .......................................................................................................................

2. .......................................................................................................................

## LET'S TALK

1. "The time that is past suffices for doing what the Gentiles want to do," Peter writes (4:3). Did your desires and urges change noticeably after you became a believer? If you cannot recall a time when you didn't walk with God, how have you experienced a change in your tastes and desires as you've grown up in your faith?

.......................................................................................................................

.......................................................................................................................

.......................................................................................................................

.......................................................................................................................

.......................................................................................................................

.......................................................................................................................

.......................................................................................................................

2. Do you struggle to trust God when he allows hardships into your life? If so, what in this week's study can help you trust him and avoid sinking down in fear when you face the next fiery trial?

.......................................................................................................................

.......................................................................................................................

.......................................................................................................................

# THE WAY HOME

## 1 PETER 5:1-14

The joy of our eternal home lies before us. We aren't there yet, but now that we've been united to Christ by faith, we are truly headed home. Our journey is hard, and Peter has shown us clearly to expect suffering along the way, but whatever pain we experience is nothing compared to the blessings that await us there. In the meantime, we walk this homeward path by following Peter's instructions for our pilgrimage, which he defined for us at the end of the last chapter: "Let those who suffer according to God's will entrust their souls to a faithful Creator while doing good" (4:19). We trust that God is doing us good, even in the midst of suffering, and because we trust him, we can press on and make the best use of our gifts and calling.

## 1. THE WALK OF GODLY SHEPHERDS (5:1-4)

Peter begins chapter 5 with detailed instructions for the ministry of church leaders, specifically for those called "elders." These elders are to lead God's people the way shepherds lead sheep.

As he begins his instructions, Peter appeals to his readers by means of his personal experience. Identify the three things Peter says about himself in verse 1:

1. ........................................................................................................

2. ........................................................................................................

3. ........................................................................................................

✤ A defining incident from Peter's past surely factors in to why he thinks of elders as shepherds and why he includes himself among them. Years before, Peter had been unwilling to suffer for Jesus. He'd thought he was willing, but as soon as he got scared, he denied even knowing his Lord. But the cowardly denial wasn't the end of the story for Peter. In fact, it was just the beginning. Read John 21:15–19 and jot down how the episode recorded there is reflected here in Peter's instructions.

.................................................................................................

.................................................................................................

.................................................................................................

.................................................................................................

✤ Peter details the way that elders are to shepherd those in their care. Note the three contrasts Peter uses in verses 2–3:

not .......................................... but ..........................................

not .......................................... but ..........................................

not .......................................... but ..........................................

In our study of 1 Peter 4 last week, we noted that Peter likely drew from Ezekiel 9:1–6 to show that God judges evil leaders for their wickedness and purifies his people through the refining fire of suffering. Now, here in chapter 5 in Peter's instructions to the elders, we find more reflections from Ezekiel.

✤ Read Ezekiel 34:1–6. How did the leaders of Ezekiel's day, the "shepherds of Israel," handle their leadership role?

.................................................................................................

.................................................................................................

.................................................................................................

.................................................................................................

Peter completes his shepherding instructions with a promise: the faithful elder-shepherds of God's people will receive a crown when Jesus, the chief shepherd, returns to bring all his people home. Peter is also putting Jesus before them as a model. Church leaders are undershepherds who should look to the chief shepherd for how to lead. Even so, there is only one who shepherds perfectly. What does Ezekiel 34:11–16 reveal about how God, through Jesus, shepherds his people?

## Red Amaranth

Winning athletes in Peter's day didn't get medals placed around their necks. They got crowns set on their heads. These crowns were actually wreaths made of flowers. The unfading crown Peter promises in 5:4 was a wreath made from the vivid red amaranth flower, which didn't fade.

## 2. THE WALK OF HUMILITY (5:5–11)

The elders are required to shepherd, but they can do so only if they have sheep that are willing to follow (v. 5). Following entails submitting to authority, which, as we've seen, can be very hard at times. For that reason, we aren't likely to follow our leaders unless we humble our hearts. And for that reason, Peter offers encouragement from Proverbs 3:34, reminding us that "God opposes the proud but gives grace to the humble" (v. 5). God's grace rests on those who follow his ways.

Peter says that we are to undertake the heart work of humbling ourselves. In other words, growing in humility is a choice we make and a discipline we practice. How, according to verse 7, do we put this discipline into practice?

........................................................................................

........................................................................................

........................................................................................

........................................................................................

What two encouragements does Peter offer in verses 6–7 for those who are willing to humble themselves?

........................................................................................

........................................................................................

........................................................................................

........................................................................................

........................................................................................

*"For God's word to be fruitful, there must*
*be a self-forgetfulness that is based on*
*trust in God regardless of circumstances."*[8]
*—Karen Jobes*

Believers can expect to suffer persecution from a hostile world, and we must also contend with our adversary the devil. Peter tells us that we contend with the devil by being "sober-minded" and "watchful" (v. 8). This is the third time in the letter that Peter has instructed God's people to be sober-minded, or self-controlled. Here in 5:8 sober-mindedness is about safeguarding ourselves from the devil's schemes. For what reasons does Peter stress the need for sober-mindedness in the other two instances?

  • 1:13

  ...................................................................................................................

  ...................................................................................................................

  ...................................................................................................................

  • 4:7

  ...................................................................................................................

  ...................................................................................................................

  ...................................................................................................................

As you consider the reasons for which Peter gives these instructions, what does it mean to be sober-minded and watchful on a practical level? In other words, how can we live out his instructions?

  ...................................................................................................................

  ...................................................................................................................

  ...................................................................................................................

  ...................................................................................................................

Peter likens the devil to a roaring lion that seeks to devour God's people. For most of us, our exposure to lions is pretty much limited to zoos and movies, so we don't get just how terrifying this image was to the very first readers of Peter's letter. To them, lions were the ferocious beasts let loose in Roman amphitheaters to tear people limb from limb. That's exactly what the devil tries to do to Christians, but ultimately he

can't succeed because he's a fake. He'd dearly love to be a ferocious lion, but that role is reserved for the true conquering lion, who is Jesus himself (see Revelation 5:5).

Even though the devil is a sham of a lion, he is still our adversary. Peter knew this from personal experience, from something Jesus had told him. Read what Jesus said to Peter in Luke 22:31–34.

✧ How is Satan exposed as Peter's adversary in Jesus's prediction?

.................................................................................................................

.................................................................................................................

.................................................................................................................

.................................................................................................................

✧ How is Jesus shown to be the true conquering lion?

.................................................................................................................

.................................................................................................................

.................................................................................................................

.................................................................................................................

✧ Surely Peter never forgot Jesus's prediction of his denial, including the role Satan would play in it, and that memory no doubt underlies Peter's words in verse 9. What does he tell us to do in this verse, and what does he want us to know?

.................................................................................................................

.................................................................................................................

.................................................................................................................

.................................................................................................................

✧ Peter gives us a four-part promise in verse 10, where we see that there will be an end to all our suffering! He also gives us a big-picture perspective on all the hardship we endure now. In light of eternity, our suffering is really only for "a little while." Deliverance might come in this lifetime, in whole or in part, but

even if it doesn't, we are guaranteed full deliverance when we are taken home to heaven. List the four aspects of the deliverance promised here.

1. ......................................................................................................................................

2. ......................................................................................................................................

3. ......................................................................................................................................

4. ......................................................................................................................................

As you think back to Peter's personal story, how did he experience this four-part promise? (You can review what happened to Peter in Luke 22:31–34, 54–62 and John 21:15–19.)

......................................................................................................................................

......................................................................................................................................

......................................................................................................................................

......................................................................................................................................

Peter ends this section of his letter with another doxology that once again reassures us that God has all power and is in absolute control of all that happens in this life, including our suffering.

## 3. THE WALK OF PETER'S FRIENDS (5:12-14)

In Peter's day, letters typically concluded with personal greetings and perhaps a few administrative matters. Peter mentions two friends by name: Silvanus, who delivers the letter, and Mark. Silvanus (perhaps better known to us as Silas) was a leader in the church and traveled with the apostle Paul. Mark wrote the Gospel that bears his name, and from what we know, he got the material for his Gospel directly from Peter.

How does Peter view his ministry colleagues?

· Silvanus

......................................................................................................................................

......................................................................................................................................

......................................................................................................................................

· Mark

........................................................................................................................

........................................................................................................................

........................................................................................................................

✧ What final instructions does Peter give in these closing verses?

........................................................................................................................

........................................................................................................................

........................................................................................................................

........................................................................................................................

Peter also sends greetings from "she who is at Babylon" (v. 13). Most likely these greetings come from the church in Rome. Like powerful cities today, the city of Rome was corrupt and worldly, opposed to God and the Christian life. At the time of Peter's letter, the ancient city of Babylon, with its corruption and abuses of power, was long gone, but its name, *Babylon*, was used to refer to similar cities, such as Rome, that had a similar reputation. (If you want to read more about Babylon as a symbol for worldly corruption, check out Revelation 18.)

✧ Compare the end of 1 Peter in 5:12–14 with the beginning in 1:1–2. What similarities do you see, and why are these similarities appropriate for both the beginning and the ending of a letter about persevering in suffering?

........................................................................................................................

........................................................................................................................

........................................................................................................................

........................................................................................................................

**LET'S TALK**

1. We can easily understand why Peter tells us to humble ourselves (5:6). What's surprising is the way he tells us to do it—by casting our anxieties on God (5:7). How do we practically cast our anxieties onto God, and how do you think this "casting" actually humbles us? In terms of your personal experience, have you seen your heart—and your life—change as a result of entrusting your troubles to God? If you haven't yet practiced Peter's principle here in 5:6–7, identify a current issue or circumstance in your life where you can begin.

2. Karen Jobes writes, "The dynamics between God, the devil, and God's people remain the same until the Lord returns, but in Christ believers have regained the power to take their stand against the prowling lion, despite the consequences, and to show themselves to be the true and faithful people of God."[9] How do we take our stand? Identify an area of your life where you can apply Peter's teaching. You might want to factor in the teaching from Ephesians 6:10–18 as well.

# 2 PETER

Peter most likely wrote this second letter near the end of his life, confined to a Roman prison awaiting execution for his faith. Despite this looming personal threat, he was gravely concerned about false teachers who were infecting the Christian communities he loved. The false teachers causing Peter such distress were telling believers to cast off biblical morals and sexual restraints and to stop living in fear of God's judgment. If this brand of false teaching has a familiar ring, it's because the exact same ideas are taught in our day.

These troublesome teachers stirred up in Peter an urgent zeal for believers to grow in their knowledge of God and the truth of God's word. This is the knowledge that safeguards us in both right beliefs and right practice. And if we possess this knowledge, we won't be tricked into believing that judgment for sin will never happen. That's vital, because Christ will return on a specific day to judge the whole world.

> *"This letter is written to establish, strengthen, and stabilize Christians in the true knowledge of God."*[10]
> —David Helm

On a side note, the short epistle of Jude (it comes just before Revelation in your Bible) has some of the exact same content as Peter's second letter. So Bible scholars wonder, did Peter borrow material from Jude, or did Jude pick up content from Peter? No one knows for sure. Perhaps Peter and Jude were both inspired by some source that's completely unknown to us now. Like students today who spend hours in the reference section of the library researching a term paper, Peter and Jude might have used

that ancient source to prepare their letters. Today we are required to give credit to the authors we quote, which we do in footnotes and bibliographies, but in Peter's day they didn't have such a system. Nevertheless, plagiarizing other writers' material was frowned upon, just as it is today. So whatever the case here with 2 Peter and Jude, it seems safe to say that it was ethical, even though we don't know how the overlap in their material actually occurred.

# KNOWING AND GROWING

### 2 PETER 1:1-21

Knowledge—we see this word five times in the first eight verses of Peter's second letter. Clearly it plays a vital role in what Peter is going to say about how we grow up in our faith and spiritually flourish in the midst of many obstacles. Also, Peter says, in order to flourish, believers must be anchored in the truth of God's word. He can testify to its truthfulness because he'd walked personally with the living Word, Jesus Christ.

## 1. A WARM HELLO (1:1-2)

Peter presents himself to his readers here using two names. The first is *Simeon*, which is simply the Hebrew spelling of *Simon*, the name he was given by his parents. The second is *Peter*, the name he was given by Jesus that means "rock." Giving both names here is a way of saying, "I am an ordinary man with a divine calling."

Not only does Peter identify himself with two names; he presents himself with two titles. What are they?

1. ........................................................................................................

2. ........................................................................................................

✦ What do these titles indicate about Peter's heart and life?

_____

_____

_____

_____

✦ How does he identify the recipients of the letter?

_____

_____

_____

_____

✦ How does Peter identify Jesus in verse 1?

_____

_____

_____

_____

✦ What sort of knowledge does Peter mention in verse 2, and what fruit does it bear?

_____

_____

_____

_____

Since knowledge plays such a key role in this epistle, it's important to grasp what Peter has in mind. He's not talking about head knowledge or even about knowing what's in the Bible. The sort of knowledge Peter is writing about is knowing God personally. He's

talking about a personal, committed relationship in which our deepest satisfaction is found in God's presence—talking to him in prayer, worshiping him with other believers, and studying all he says to us in his word. This is the knowledge Peter wants for his readers.

## 2. GROWING A GRACE-BASED LIFE (1:3–11)

Peter dives right in to the heart of his message with instructions for godly living. He knows that as we grow in our knowledge of God, we'll recognize more fully his grace and mercy in our lives, and this in turn promotes our pursuit of godliness.

✝ We are told in verse 3 that God's power has given us all we need for godly living. Look at the verb tense Peter uses: "His divine power *has granted* . . ." What does this verb tense communicate?

.........................................................................................................

.........................................................................................................

.........................................................................................................

.........................................................................................................

.........................................................................................................

.........................................................................................................

.........................................................................................................

.........................................................................................................

✝ Still pondering verse 3, how do we lay hold of all we've been given for godly living?

.........................................................................................................

.........................................................................................................

.........................................................................................................

.........................................................................................................

Peter tells us that we've been called to God's glory and excellence (v. 3), and along with this calling, we've been given "precious and very great promises" (v. 4). How does Romans 8:28–32 shed light on the nature of these promises?

Look again at verse 4. What happens to us as a result of these promises?

"For this very reason," Peter writes (v. 5)—in other words, because we have been given all we need to live holy lives, and because we have received the promises and have escaped worldly corruption—we are to grow up spiritually. Peter supplies us with a list of virtues, or godly traits, that grow one from another. Before he begins his list, what does he say is the part we are to play in pursuit of these traits?

The first trait Peter names is *faith* (v. 5). It is the necessary root from which all spiritual growth springs. To faith we are to add *virtue*. It's the same Greek word translated in verse 3 as *excellence*: ". . . who called us to his own glory and excellence." Whichever English word we use, it's about being all-around committed to

a godly lifestyle. From there, we add *knowledge*. As we know by now, knowledge is mentioned several times in this letter, and when Peter uses the word, he has in mind the kind of knowing that happens in close relationships. We *know* our own child. Our best friend *knows* us. In the Bible, knowing someone sometimes implies physical intimacy, like when "Adam *knew* Eve his wife, and she conceived" (Genesis 4:1). So here in this context, Peter is saying that we are to devote ourselves to knowing God better and better—not primarily head knowledge but a relational sort of knowledge that comes from personal experience.

> *"These are the fountainhead gifts that all followers of Jesus have in their possession— the knowledge and promises of God."*[11]
> —David Helm

The next two virtues are *self-control* and *steadfastness* or *perseverance* (v. 6). Why do you think self-control necessarily comes before steadfastness?

*Brotherly affection* and *love* (v. 7) are last on Peter's list, not because they are least important but because they are most important. (If you've got some extra study time this week, read 1 Corinthians 13 for the apostle Paul's take on love.)

## Peter's "Virtue" List
## 2 Peter 1:5-7

| Christian Trait | Definition |
| --- | --- |
| Faith | Living by grace in Christ, trusting confidently in the promises of God |
| Virtue | Committing to a holy lifestyle |
| Knowledge | Knowing God relationally |
| Self-control | Governing fleshly passions |
| Steadfastness | Persevering with Christ day in and day out |
| Godliness | Devoting every area of life to God |
| Brotherly affection | Strengthening relational bonds |
| Love | Pouring out our lives sacrificially for others |

✣ What does Peter reveal about these Christian traits in verse 8?

......................................................................................................

......................................................................................................

......................................................................................................

......................................................................................................

✢ Peter describes someone who fails to grow up in these ways as "so nearsighted that he is blind" and forgetful of the gospel (v. 9). Think for a moment about the vision of nearsighted people. What aspect of seeing is difficult for nearsighted people? How do you think this applies to someone's spiritual life?

......................................................................................................................

......................................................................................................................

......................................................................................................................

......................................................................................................................

In verses 10–11 Peter urges us to practice these eight virtues so that we do not fall away but instead will find our way to heaven. So is Peter actually saying that perfecting these virtues is required to get into heaven or to receive blessings from God? He definitely is not! His point is that only people who really and truly belong to Christ can ever even hope to grow in these virtues, but all those who really and truly *do* belong to Christ can't help but grow in them.

### 3. PETER'S PASSION (1:12–15)
Because living out the eight qualities named in verses 5–7 exposes us to the many blessings of belonging to Christ, Peter is committed to setting them in front of his readers frequently.

✢ What gives a sense of urgency to Peter's desire to establish Christians on the path of discipleship?

......................................................................................................................

......................................................................................................................

......................................................................................................................

......................................................................................................................

Peter never forgot the day when Jesus restored him to ministry after his denial. Jesus hinted that day something about the way Peter would eventually die. What did Jesus tell Peter in John 21:18–19 that Peter references here in verse 14?

## 4. SURE AND TRUE (1:16-21)

As we will see a bit later in this letter, certain people claiming to be teachers were hanging around and spreading lies about the Lord. They also spoke scornfully of Peter and the other apostles for teaching that Jesus will return one day and judge people for their sins. These false teachers said that the apostles' views were outdated and unreliable, really no better than a fairy tale, and they were attracting a following. That's why Peter is so concerned that his readers believe his message.

What is the first reason Peter gives for why his teaching about the Lord is trustworthy (v. 16)?

Read Matthew 17:1–8. Identify the ways Peter uses this incident from Matthew's Gospel to make his case in verses 17–18.

More enduring and far-reaching than Peter's personal experience of Jesus is what the Old Testament prophesied about him. Only Peter, James, and John were invited to witness the miracle on the mountain—what theologians call the "transfiguration"—but all believers in every age are invited to know Jesus and see him even more fully in God's word. That's what Peter writes about in verse 19.

✦ What imagery does Peter use to describe God's word in verse 19? How does that imagery work to reinforce the point he is making?

.......................................................................................................................

.......................................................................................................................

.......................................................................................................................

.......................................................................................................................

✦ Peter mentions the dawning of "the day" in verse 19, and we'll look more closely at what he means when we study 2 Peter 3. Here he also mentions "the morning star." This very star was first spoken about by an Old Testament prophet named Balaam, and the star appears elsewhere in the Bible as well. Read the following verses and identify this morning star: Numbers 24:17; Matthew 2:2; and Revelation 22:16.

✦ Summarize what Peter is teaching in verses 20–21.

.......................................................................................................................

.......................................................................................................................

.......................................................................................................................

.......................................................................................................................

**LET'S TALK**

1. Do you find it hard to trust in what you cannot see or hear or touch? How does this chapter of Peter's letter help you understand why faith doesn't hinge on what we can grasp with our senses?

..................................................................................................................

..................................................................................................................

..................................................................................................................

..................................................................................................................

..................................................................................................................

..................................................................................................................

2. Look again at Peter's "virtue list" in verses 5–7. Describe from your own experience, or from what you have observed in the experience of others, how one trait builds on another. Can you identify a particular example of this progression in your own life?

..................................................................................................................

..................................................................................................................

..................................................................................................................

..................................................................................................................

..................................................................................................................

..................................................................................................................

# FRENEMIES AND FALSE TEACHERS

### 2 PETER 2:1-10a[12]

God's word is true, and those who believe it and live by it are blessed. That's been Peter's emphasis so far in the letter, and now we discover why—certain people claiming to be theology teachers had infiltrated the Christian community. These false teachers were twisting God's truth with lies and enticing some believers toward a path of destruction. Here Peter exposes their lies and equips us with ways to recognize false teachers and avoid their trap.

## 1. WATCH OUT! (2:1-3)

False prophets, or false teachers, are nothing new. They have always operated in and among God's people, which Peter makes clear in verse 1. These false teachers spread what Peter calls "destructive heresies," which are ideas that warp the truth about God. And Peter says that they do it "secretly" (v. 1). His point is that false teachers don't announce that they are false. Instead they gain ground by appealing to people's desires, leading some to question the true goodness and power of God.

✦ What particular traits of false teachers does Peter identify in verses 1–3?

.......................................................................................

.......................................................................................

.......................................................................................

✦ What effect do false teachers have on the people they fool?

.................................................................................

.................................................................................

.................................................................................

.................................................................................

✦ What does Peter indicate here as the inevitable end of these false teachers?

.................................................................................

.................................................................................

.................................................................................

.................................................................................

## 2. IF . . . THEN (2:4–10a)

The false teachers in Peter's day were claiming that people could live however they pleased, indulging in whatever sensual delights appealed to them, because, the false teachers said, the idea of a final judgment is just a myth. People latched onto these lies because the message was so sensually appealing. The same thing happens today, right? Our earthly desires can exert a powerful, influential pull on our convictions. So we want to be aware of this when the path of discipleship means we must deny ourselves in sometimes painful ways. We want to do all we can to avoid being drawn into the sort of message these teachers spread.

✦ List the main point in each of the "if" statements that appear in verses 4–8.

v. 4 .........................................................................

v. 5 .........................................................................

v. 6 .........................................................................

v. 7 .........................................................................

Peter is making an argument here: if God can do X and X and X and X, he is well able to keep his promises to you and me and all his people.

✦ The first "if" in his argument focuses on angels, specifically fallen angels. We don't know for sure what event Peter had in mind in verse 4 when he writes of the angels who sinned. Jude, in his epistle, writes almost the exact same thing (Jude 6). These angels who sinned might be the beings called "sons of God" in Genesis 6:1–4. Those beings committed some sort of sexual perversion with women. But Peter might have had something else in mind, perhaps the fall of angels from heaven. Whatever the specific sin and whenever it might have occurred, what happened to these angels?

........................................................................................

........................................................................................

........................................................................................

........................................................................................

✦ Who was judged in the second "if" (v. 5), and who was spared?

........................................................................................

........................................................................................

........................................................................................

........................................................................................

✦ Peter calls Noah "a herald of righteousness" in verse 5, even though, if you read Noah's story in Genesis, you won't find any record of his actually heralding, or preaching. How do Genesis 6:9; 7:1, 23; 8:13–22; 9:1–2, 8–17 reveal why Peter might have referred to Noah as a herald of righteousness?

........................................................................................

........................................................................................

........................................................................................

........................................................................................

◆ Residents of the ancient cities of Sodom and Gomorrah were those judged in Peter's third "if" (v. 6), but a man named Lot and his two daughters were spared. Read Genesis 19:1–38 to get the entire backstory. What did God do to those cities?

................................................................................................................................

................................................................................................................................

................................................................................................................................

................................................................................................................................

◆ List the things Peter says about Lot in verses 7–8.

................................................................................................................................

................................................................................................................................

................................................................................................................................

................................................................................................................................

As you consider Lot and what we know about him from Genesis 19, it seems surprising that Peter calls Lot "righteous." After all, Lot was reluctant to leave Sodom despite all the wickedness pressing in on his family and despite the angels' persistent urging. And Lot offered up his daughters to the perverted men knocking down his door, and later he allowed his daughters to get him drunk and sin with him sexually. So the fact that Peter calls Lot "righteous" surely points to something besides Lot himself. It points to the gospel. Lot is counted righteous, despite his sins and failings, because he had faith, and that is the only way anyone is counted righteous in God's eyes.

◆ With the *ifs* covered—"If . . ." (vv. 4–7)—we come to Peter's "then . . ." in verse 9. What two truths about God does Peter identify here in verse 9?

1. ................................................................................................................................

2. ................................................................................................................................

◆ What two sins does Peter identify in the first portion of verse 10 as warranting severe judgment?

1. ................................................................................................................................

2. ................................................................................................................................

Where in each of the Old Testament examples that we've examined in this lesson do you see one or both of these sins being committed?

· In the angels' story:

.............................................................................................................

.............................................................................................................

.............................................................................................................

· In Noah's story:

.............................................................................................................

.............................................................................................................

.............................................................................................................

· In Lot's story:

.............................................................................................................

.............................................................................................................

.............................................................................................................

## LET'S TALK

1. The false teachers in Peter's day made headway because they appealed to people's sensuality. They taught that believers could participate in sin and enjoy its pleasures with no consequences, and many were all too eager to believe it. Can you identify teaching of a sensual nature impacting Christians today?

.............................................................................................................

.............................................................................................................

.............................................................................................................

......................................................................................................

......................................................................................................

......................................................................................................

......................................................................................................

2. "The Lord knows how to rescue the godly from trials," Peter writes (v. 9). That includes the trial of resisting false teaching and anything else that threatens our faith. How have you experienced God's rescue in your own life, or where do you need to experience it right now? Consider also 1 Corinthians 10:13.

......................................................................................................

......................................................................................................

......................................................................................................

......................................................................................................

......................................................................................................

......................................................................................................

......................................................................................................

......................................................................................................

# WATERLESS SPRINGS

## 2 PETER 2:10b-22

Never one to sugarcoat, Peter continues his blunt warning about false teachers, exposing their true nature in stark terms. If you recall, the message being peddled by these false teachers had two main ideas. First, they said, there is nothing wrong with indulging in sensual pleasures of every kind. The second idea flowed from the first: live however you like because ultimately God won't judge anyone for sin. Does this ring a bell? Most likely it does, because the same heresies are fooling people today. There are churches that declare, "God wants us to celebrate all lifestyle choices." These preachers downplay God's hatred toward sin and the reality of God's ultimate judgment against it. Peter's very own life exposes the falseness of these teachers. He'd failed his Lord miserably and been forgiven and restored, but he never downplayed the reality of God's judgment. If anything, he gives us here one of the most direct warnings of coming judgment in the entire New Testament.

## 1. BOLD AND BAD (2:10b-16)

We pick up this week with the second half of verse 10: "Bold and willful, they do not tremble as they blaspheme the glorious ones." Wait—what? We need to stop here for a minute and see what Peter is talking about. To *blaspheme* is to speak disrespectfully about something or someone holy. Here, the false teachers are blaspheming "the glorious ones." Although we don't know for sure the identity of these glorious creatures, they were most likely angels.

✦ *Bold, willful,* and *fearless*—how would you summarize what these traits add to our understanding of the false teachers?

.......................................................................................................

.......................................................................................................

.......................................................................................................

.......................................................................................................

✦ We have to understand why these teachers wanted to blaspheme, or slander, angels. Well, we know by now that the false teachers were promoting the lie that no final judgment will ever happen. With that in mind, look at Matthew 13:40–43. What do you see there that contradicts the false teachers and perhaps explains why they wanted to slander the angels?

.......................................................................................................

.......................................................................................................

.......................................................................................................

.......................................................................................................

When it comes to discerning who's righteous and who's wicked, only the Lord is truly qualified. That's the point Peter makes in verse 11 when he writes that even the most powerful angels aren't equipped to pass judgment on others.

✦ What does Peter add to his character assessment of false teachers in verse 12?

.......................................................................................................

.......................................................................................................

.......................................................................................................

.......................................................................................................

✦ What happens to those who stubbornly cling to their heresies?

.......................................................................................................

........................................................................................

........................................................................................

........................................................................................

✦ Peter tells us that the false teachers "count it pleasure to revel in the daytime" (v. 13). In other words, they are so entrenched in evil that they don't even bother to hide their decadent behavior behind the dark of night. What do the following passages add to our understanding of the character of false teachers?

• Ecclesiastes 10:16–17

........................................................................................

........................................................................................

........................................................................................

• Isaiah 5:11

........................................................................................

........................................................................................

........................................................................................

• Romans 13:13

........................................................................................

........................................................................................

........................................................................................

Calling the false teachers "blots and blemishes," Peter says that they find great delight in their sin, and they do it in the company of Christians who are gathered together to share the Lord's Supper and enjoy a meal (vv. 13–14). These false teachers wanted to make this holy gathering more like the worldly, overindulgent Roman feasts that they loved.

✛ Peter names five more characteristics of the false teachers in verse 14. List them here:

1. ......................................................................................................................................

2. ......................................................................................................................................

3. ......................................................................................................................................

4. ......................................................................................................................................

5. ......................................................................................................................................

✛ The heretics were attracting people whom Peter calls "unsteady souls" (v. 14). How do 2 Peter 3:16 and James 1:5–8 shed light on what makes them unsteady?

......................................................................................................................................

......................................................................................................................................

......................................................................................................................................

......................................................................................................................................

In verses 15–16 Peter highlights the greed of false teachers, and he compares them to an Old Testament prophet named Balaam, whose story is found in the book of Numbers (read Numbers 22, especially verses 21–35). Balaam was the kind of prophet who would sell his prophecies for money, and he had a reputation for being able to call down blessings and curses on people, which he would do for cold, hard cash.

Back in those days, Balak, king of the Moabite people, tried to hire Balaam to curse God's people, Israel, but the Lord told Balaam to forget about it; it would never work. Nevertheless, Balaam was greedy for the large sum that King Balak had offered him, so he tried to go ahead with the curse despite the Lord's clear instructions. But then a miracle occurred—the Lord gave human voice to a donkey to rebuke the greedy Balaam.

Balaam never was able to curse God's people. Every time he tried, God turned Balaam's curse words into a blessing. So the devious prophet sought to destroy God's people another way, by enticing them to commit sin (Numbers 31:16). He caused great harm in the process, but in the long run, Balaam himself was judged by God and killed.

✦ In what ways, according to Peter, are the false teachers like Balaam?

........................................................................

........................................................................

........................................................................

........................................................................

## 2. WATERLESS SPRINGS AND STORMY MISTS (2:17–22)

God's judgment will eventually fall on false teachers who, in their greed and lust for pleasure, lead people away from God and his truth. And their end isn't pretty.

✦ Picture in your mind Peter's imagery of false teachers as "waterless springs and mists driven by a storm" (v. 17). What do these images imply about the false teachers and the messages they bring?

........................................................

........................................................

........................................................

........................................................

........................................................

........................................................

........................................................

........................................................

........................................................

---

### Balaam

"Balaam was a well-known non-Israelite prophet. Balak, the king of Moab, was terrified of the Israelites, and so he summoned Balaam to place a curse on them. God spoke to Balaam, however, and forbade him to curse Israel. He permitted Balaam to go to Balak on the condition that he speak only as the Lord instructed. God reinforced this condition in a grimly humorous episode involving a talking donkey. Balak tried many times to persuade Balaam to curse Israel, but his plan backfired. Balaam instead pronounced four blessings on the nation. Although Balaam was unable to curse the Israelites, he later advised Balak to send women to seduce Israel away from God and into idolatry."[13]

✦ What do the false teachers use to entice those with weak faith (v. 18), and what do they promise (v. 19)?

........................................................................

........................................................................

........................................................................

........................................................................

✦ What does Peter mean when he writes that "whatever overcomes a person, to that he is enslaved" (v. 19)? Glance at John 8:34 and Romans 6:6 to help you answer.

........................................................................

........................................................................

........................................................................

........................................................................

✦ We find a scary warning in verses 20–22 about those who take part in the blessings of God's people but then turn away from God when they realize they must give up sinful pleasures and passions. Where does this leave them?

........................................................................

........................................................................

........................................................................

........................................................................

✦ True Christians can never lose their salvation. This is true because of what theologians call the "perseverance of the saints." It means that once we have been united to Christ by faith, we can never fall away. How, according to the following passages, is this possible?

   · John 10:27–28

........................................................................

........................................................................

........................................................................

· Romans 8:29–30

· Philippians 1:6

· Jude 24

✟ True Christians can never fall away, but the false teachers Peter writes about do fall away. What does this tell us about the false teachers?

✟ Peter quotes Proverbs 26:11 at the end of the chapter. What specific imagery in the proverb reinforces our understanding of the true character of the false teachers?

## LET'S TALK

1. False teaching appeals to us through promises of sensual pleasure and freedom from consequences. To make it personal, are there particular false teachings that tend to attract you? If so, what about them appeals to you?

2. Peter has warned us to safeguard ourselves in the truth of God's word and to avoid being led away from Christ by false teaching. At the same time, once we are united to Christ, we can never lose our salvation. Review some of the passages that reveal this truth (John 10:27–28; Romans 8:29–30; Philippians 1:6; and Jude 24). How does this encourage us to live as obedient disciples rather than to take our salvation for granted and live as we please?

# THE DAY WILL COME!

### 2 PETER 3:1-18

"Beloved"—that's how Peter addresses his readers four times in this final chapter (vv. 1, 8, 14, 17). Clearly he is deeply devoted to them and concerned for their welfare, which is why he has written two such passionate letters. Peter writes this second letter as he nears the end of his life, so he is all the more eager to remind his believing friends that Jesus Christ is sure to return. At the same time, he also warns them that when Jesus comes, there will be a final judgment for sin. For that reason, Peter intensely desires that his friends stay the course of discipleship and avoid the allure of false teaching.

## 1. HIDDEN IN PLAIN SIGHT (3:1-7)

As Peter begins to wrap up this letter, he urges his friends to remember all they have learned about salvation from both "the predictions of the holy prophets" and "the commandment of the Lord and Savior" that the apostles teach (v. 2). If we stand back from verse 2 and look at the big picture of the letter, we can figure out what he's getting at here.

✛ How do the following passages—one spoken by a prophet and one by the Lord Jesus—help us identify what Peter wants us to remember?

• Jeremiah 25:30–31

· Matthew 25:31–46

What do we see in verses 3–4 about why this kind of remembering is so important?

Peter refers to the false teachers as "scoffers" (v. 3). The book of Proverbs says a lot about scoffers. From the following proverbs, shape a short description of a scoffer: Proverbs 1:22; 9:8; 13:1; 14:6; 15:12; 21:24; 22:10; 24:9; 29:8.

Scoffers are cynical people, and we see this clearly in the cynical question the false teachers were asking: "Where is the promise of his coming?" (v. 4). They backed up their cynicism by reasoning that if God were really coming to judge sin, he would have come by now. Nothing ever changes, they said, and instead the earth flows along like it always has. Wrong! Peter reminds his readers that not only is God vitally involved with the earth—he is the very one who created it! And they mustn't forget that God had already come in judgment, flooding the world in the days of Noah.

✦ According to Genesis 8:13–17, what happened to the earth after the flood?

.................................................................................................................

.................................................................................................................

.................................................................................................................

.................................................................................................................

✦ Peter says that the scoffers "deliberately" overlook God's work in the world (v. 5). What does Romans 1:18–21 add to our understanding of Peter's word choice here?

.................................................................................

.................................................................................

.................................................................................

.................................................................................

.................................................................................

.................................................................................

.................................................................................

.................................................................................

.................................................................................

.................................................................................

### Remembering

2 Peter 3:2 isn't the first time in the Bible where the instruction to *remember* is given. In fact, the command to remember God's work and ways is important from the earliest days of God's people. Moses regularly instructed the Israelites to remember God's work on their behalf (Deuteronomy 8:2–3), as did Joshua after him (Joshua 1:13). The psalmists and the prophets show us the blessings of remembering (Psalm 63:5–6; Isaiah 64:5), and in the Gospels we see how remembering strengthens our faith (John 2:22; 12:16).

God created the world with his word, and by that same word, the world as we know it will come to an end. What does verse 7 reveal about what will happen on that day?

_____

_____

_____

_____

## 2. THE PATIENCE OF GOD (3:8-10)

Peter reveals a comforting facet of God's character in this section—patience. And with all this talk of judgment day, we need this encouragement right about now. Yet Peter gives us a warning here as well.

How is God's perspective on time different from ours?

_____

_____

_____

_____

The false teachers scoff at the idea that Jesus will return, but Jesus promised that he would (v. 9), even if the timing of his return is delayed. What does Peter reveal as the reason for the Lord's delay?

_____

_____

_____

_____

Peter tells us that God desires for everyone to repent of sin. This doesn't mean, however, that everyone will be saved. If that were the case, Peter would have no need to warn about God's judgment! Yet we mustn't picture God up in heaven wringing his hands

over people who refuse to repent, as if people's salvation is outside of God's control. He is very much in control of the destiny of every human being. It's best to understand Peter's words—"The Lord is not slow to fulfill his promise . . . not wishing that any should perish, but that all should reach repentance" (v. 9)—as an indication of God's kind heart toward everyone he has made and of his intention to save from judgment everyone united to Christ by faith. We can better understand Peter's teaching when we look at something that the apostle Paul wrote:

> We know that for those who love God all things work together for good, for those who are called according to his purpose. For those whom he foreknew he also predestined to be conformed to the image of his Son, in order that he might be the firstborn among many brothers. And those whom he predestined he also called, and those whom he called he also justified, and those whom he justified he also glorified. (Romans 8:28–30)

✛ A day of judgment, what Peter calls "the day of the Lord," will surely come, and it will come "like a thief" (v. 10). Peter got that image directly from Jesus himself. Read what Jesus said in Matthew 24:42–44 and then jot down what the thief image means here in Peter's description.

......................................................................................................................

......................................................................................................................

......................................................................................................................

......................................................................................................................

## 3. IT MATTERS HOW WE LIVE (3:11–13)

How should we live our lives in light of the end that is surely coming? That's what Peter wants us to consider next.

✛ What incentive does Peter give in verse 12 for pursuing holiness and living lives devoted to the Lord?

......................................................................................................................

......................................................................................................................

......................................................................................................................

......................................................................................................................

No human being determines the beginning or end of anything on earth or in heaven. Even so, God works out his predetermined plans and set dates and times through the actions of human beings.

Peter tells us that "the heavenly bodies will melt as they burn" (v. 12), but if you look carefully, he does not say the same thing about the earth. (Some Bible translations say that everything—both heavens and earth—will be burned up, but Peter's words are best translated with this difference between the heavens and the earth.) Throughout Scripture, we see God as one who renews rather than destroys what sin has damaged, and we see hints of this very thing in verse 13, where Peter writes about God's "promise." What does Revelation 21:1–5 reveal this promise to be?

......................................................................................................................................

......................................................................................................................................

......................................................................................................................................

......................................................................................................................................

## 4. PETER'S FINAL PLEA (3:14–18)

As Peter closes his final letter to these Christians he loves dearly, he takes one more opportunity to encourage them to trust in the reliability of Scripture and the promises of God.

Those who trust God's promises wait for him, and they live their lives in a spirit of expectation of seeing those promises fulfilled. According to verse 14, how is living in expectation meant to motivate us?

......................................................................................................................................

......................................................................................................................................

......................................................................................................................................

......................................................................................................................................

✦ Peter reinforces what he said earlier about the Lord's patience, and then he mentions his ministry colleague, the well-known apostle Paul (vv. 15–16). What does Peter say about Paul's letters, and how does he classify them?

.........................................................................................................................

.........................................................................................................................

.........................................................................................................................

.........................................................................................................................

✦ What caution does Peter give in verse 17?

.........................................................................................................................

.........................................................................................................................

.........................................................................................................................

.........................................................................................................................

✦ In what way does verse 17 circle back to 2 Peter 1:12 at the beginning of the letter?

.........................................................................................................................

.........................................................................................................................

.........................................................................................................................

.........................................................................................................................

✦ What is Peter's final instruction (v. 18), and what did he give his readers earlier in the letter (2 Peter 1:3–8) for how to carry out this final instruction?

.........................................................................................................................

.........................................................................................................................

.........................................................................................................................

.........................................................................................................................

Peter ends with a beautiful doxology, and it's kind of unusual. Most of the doxologies we find in the New Testament are written to praise God the Father. This one, in verse 18, honors Christ Jesus. Peter knew the Lord as both human friend and sovereign Lord, and he loved Jesus more than life itself. "To him be the glory" indeed. Come, Lord Jesus!

## LET'S TALK

1. Waiting—we all have to do it, sometimes for long periods of time. Peter assumes that we're waiting in a spirit of expectation for Christ's return, when we'll be taken to our forever home (v. 14). Waiting takes patience, of course, and that's an attribute of God's character that Peter highlighted this week. God is never in a hurry, whether it comes to his big overarching purposes for the world or to his purposes for our very own lives. Is there something for which you've waited and prayed a long time? What from this week's study encourages you in your waiting? Or has what we've studied this week changed your perspective on this long-held desire?

2. Discuss some practical ways we can do what Peter tells us at the end of the letter: "Grow in the grace and knowledge of our Lord and Savior Jesus Christ" (v. 18).

3. As we end our study of 1–2 Peter, summarize what you have learned about:

· the big story of the whole Bible:

· the character of Almighty God:

· salvation in Jesus Christ:

# HELPFUL RESOURCES
## ON 1–2 PETER

Clowney, Edmund. *The Message of 1 Peter*. The Bible Speaks Today. Edited by John R. W. Stott. Downers Grove, IL: InterVarsity Press, 1988.

Helm, David R. *1–2 Peter and Jude: Sharing Christ's Sufferings*. Preaching the Word. Edited by R. Kent Hughes. Wheaton, IL: Crossway, 2015. First published 2008.

Jobes, Karen. *1 Peter*. Baker Exegetical Commentary on the New Testament. Grand Rapids, MI: Baker Academic, 2005.

Smart, Dominic. *When We Get It Wrong: Peter, Christ, and Our Path through Failure*. Revised Edition. Fearn, Ross-shire, UK: Christian Focus, 2019.